ROYAL WEDDINGS
THROUGH TIME

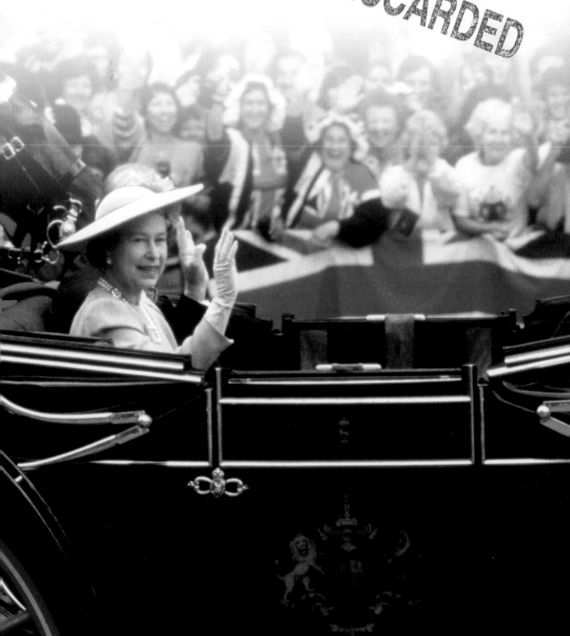

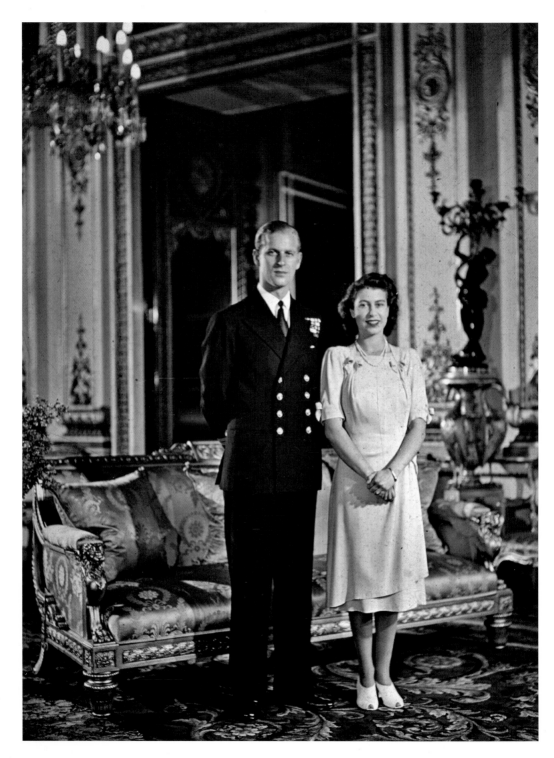

Princess Elizabeth and Prince Philip.

ROYAL WEDDINGS
THROUGH TIME
JANETTE McCUTCHEON

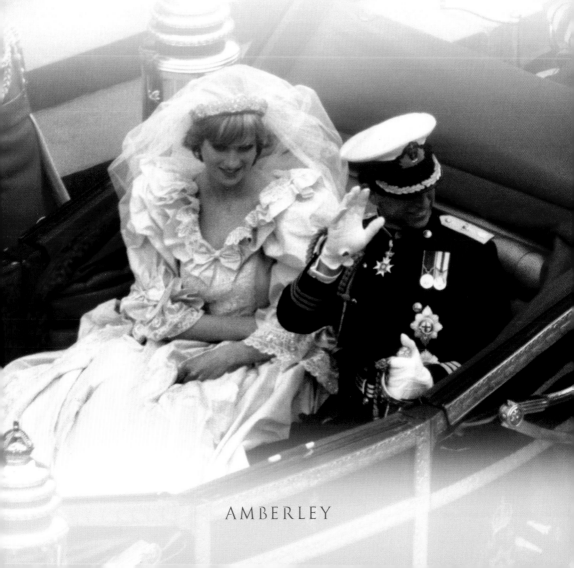

AMBERLEY

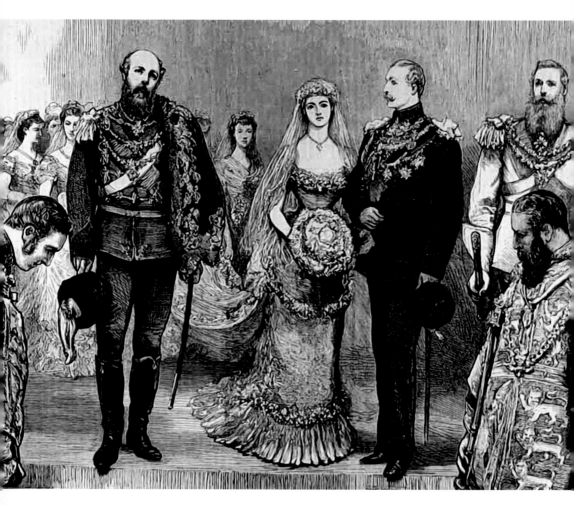

The wedding of the Duchess of Connaught in 1879.

First published 2011

Amberley Publishing
The Hill
Stroud, Gloucestershire, GL5 4 ER

www.amberley-books.com

Copyright © Janette McCutcheon, 2011

The right of Janette McCutcheon to be identified
as the Author of this work has been asserted in
accordance with the Copyrights, Designs and
Patents Act 1988.

ISBN 978 14456 0440 4

British Library Cataloguing in Publication Data.
A catalogue record for this book is available from
the British Library.

Typeset in 9.5pt on 12pt Celeste.
Typesetting by Amberley Publishing.
Printed in the UK.

Contents

Princess Mary was the third child of King George V and Queen Mary. She married Lord Lascelles on 28 February 1922 in Westminster Abbey. It was the first time that her friend Elizabeth Bowes-Lyon had taken part in a royal event.

Introduction

On 29 April 2011, Prince William marries his fiancée, Catherine Middleton. This is a love story in the truest sense. They will marry for love, having met at University and been together for eight years. It will also be an unusual marriage in that a 'commoner' will be marrying a future King of the United Kingdom and will eventually become our Queen. For centuries, our royal family has married into other royal families for many reasons – economic, social, political or even just to preserve the royal blood line. However, this time it will be different. Our Royal Family has come to realise that, in the twenty-first century, while it is useful to have connections to other Royal families, it is not quite as necessary as it once was. It is more important to have a happy, loving marriage.

As for myself, my interest in the Royal Family was sparked in February 1981 when another royal wedding was announced: Charles and Diana. In an era before supermodels and 'celebrity' became the norm, Diana was a rare and beautiful icon. To me she was amazing. Yes, she was connected to royalty, but she had that common touch. She had been a young woman who worked for a living and had her own life before becoming a member of the Royal Family. She was an inspiration. For a ten-year-old girl she was a true princess in every sense of the word. Like many young girls of that era, I started a journey at that point, collecting magazines, newspapers and memorabilia related to the royal couple. If it had 'Diana' on it, I wanted it. Her fashion sense, style and looks were adopted by the nation's girls. I ended up with the Diana 'hairdo'; the Diana hats followed Diana's fashions. On holiday, I even bought a copy of her engagement ring with my pocket money. I still have it. My one regret is not being in Britain for her wedding. My parents and I were booked on the last flight to arrive into Britain before the royal wedding. Unfortunately, it was four hours late and we missed the great day! (I'd never been on a Boeing 747 so quiet though, with only about 100 people on board. It was like having our own private jet across the Atlantic!) When I got home, my grandparents and aunt had decked our house out in bunting and banners for the royal occasion. It was overwhelming!

Weddings are a cause for celebration. They are happy events where two people in love should be able to share their happiness with everyone around them. Unfortunately, in this day and age, we have become cynical and money-orientated. For many people however, the royal wedding is a happy time to connect with their community and bring out the best in themselves – whether this is a street party or running a commemorative event.

Within the pages of this book are a small selection of Royal Weddings through time, it is by no means an exhaustive account, but gives a flavour of those weddings which have changed the course of history, have sparked a true love or have had a major effect on the nation. I hope you enjoy it as much as I enjoyed compiling this short history.

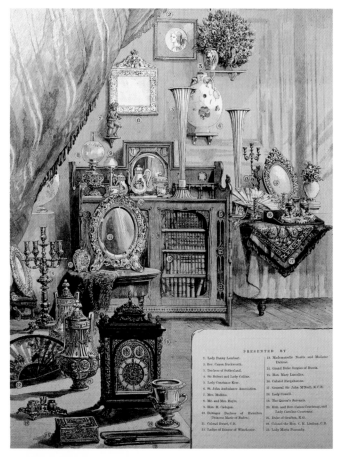

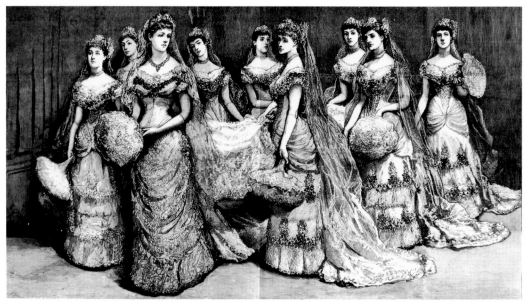

Some of the wedding gifts of Princess Beatrice and Prince Henry of Battenberg

The wedding of Prince Leopold, 1882, this view showing the bride and bridesmaids.

❧ CHAPTER 1 ❧
From William and Catherine to Victoria and Albert

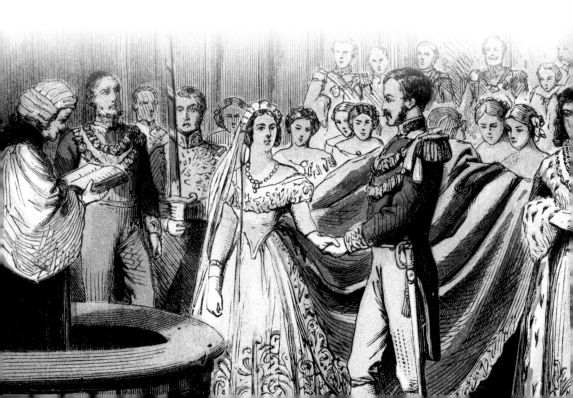

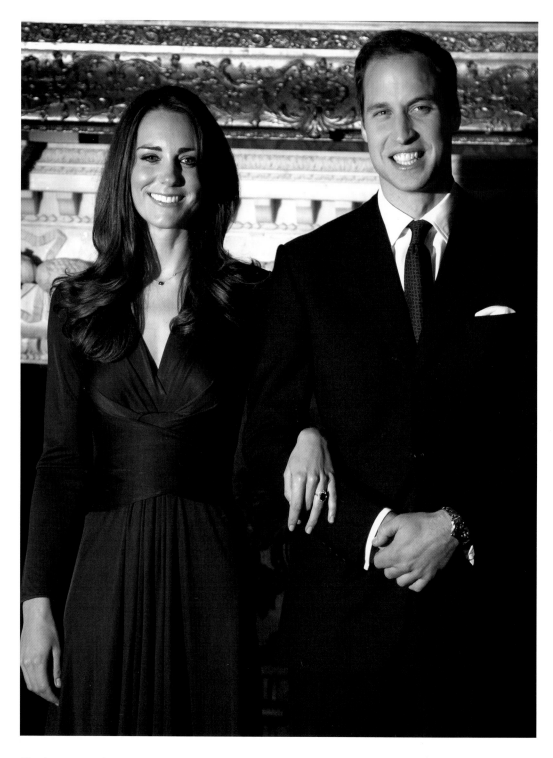

The happy couple.

PRINCE WILLIAM & CATHERINE MIDDLETON

William Wales met Catherine Middleton while they were studying at St Andrews University in Scotland. William had gone there to study History of Art, and met Catherine, who was a fellow History of Art student. They soon became friends and it was Catherine who supported William when he decided to switch courses to Geography. They both graduated on 23 June 2005 with 2:1 Honours degrees.

After eight years together, William and Catherine announced their engagement on 16 November 2010. Catherine walked into the grand Entrée Room at St James' Palace on the arm of her future husband. Wearing a beautiful, royal blue jersey dress, by her favourite designer Issa, which matched her engagement ring – worn by his late mother, Diana, Princess of Wales. The ring has an 18-carat blue sapphire surrounded by diamonds. It was designed by Garrard.

As little is known of their wedding except as yet, that it will be in Westminster Abbey and Catherine will break away from royal tradition and travel to the ceremony in a car instead of a Royal Coach. This will be the first time a future Queen has travelled to her wedding by car instead of a Royal Coach. However, once married, the couple will travel back to Buckingham Palace in a glass carriage. It is at Buckingham Palace that the Queen will host a Reception and a private dinner. This will be followed by dancing and celebrations late into the evening.

The Ceremony will start at 1100 hours and will be conducted by the Dean of Westminster. The Archbishop of Canterbury will marry them.

A few speculations have been made about the wedding ring. It is likely, and in keeping with royal tradition, that the wedding ring will be made from Welsh gold. This tradition was first laid down by HRH The Queen Mother in 1923. Unfortunately, it cannot come from the same nugget as The Queen's, Princess Margaret's, The Princess Royal's and Princess Diana, as there is very little of it left. So another nugget will have to be found.

Catherine's dress is to be designed by Sarah Burton, who worked for Alexander McQueen. Catherine's best friend Sarah Buys had her dress designed by Burton in 2005 when she married Tom Parker Bowles.

William

William Arthur Philip Louis was born on 21 June 1982 at St Mary's Hospital, Paddington. His parents are His Royal Highness Prince Charles, Prince of Wales, and the late Princess Diana, Princess of Wales. His maternal grandparents are Queen Elizabeth II and Prince Philip, Duke of Edinburgh. He is second in line to the throne, after his father. He has one younger brother, Prince Harry. He was christened in the Music Room at Buckingham Palace on 4 August 1982 by the Archbishop of Canterbury.

His education began at Mrs Mynor's School, in London, then Wetherby School, where his mother would often walk him and his brother to school. Next came Ludgrove School, and then on to Eton where he obtained his A Levels in Geography, Biology and History of Art. At school he enjoyed football and took up water polo.

On 31 August 1997, when Prince William was fifteen, his mother died in a car crash in Paris. Her funeral was on 6 September 1997 at Westminster Abbey. Prince William formed part of the funeral cortege when he walked behind her coffin with Prince Charles and Prince Harry.

After Eton, he took a gap year. During this time he took part in the Raleigh International Programme, helping children in Southern Chile and taking part in British Army exercises in Belize. 2001 saw William enter St Andrews University, where he successfully gained a 2:1 in Geography. He carried on his love of water polo and took part in the Celtic Nations Tournament in 2004 as part of the Scottish National Universities team.

Upon completing his university education, he followed the family tradition of entering the Armed Forces. He completed his Officer training at the Royal Military Academy at Sandhurst and graduated from there in December 2006. He then followed his father, uncle and grandfather into active service. He went through Royal Navy and Royal Air Force training and undertook a commission with the Air Force to gain his RAF Wings. He saw active service in the Afghan Conflict. Back in the Navy, he underwent further training and now he is now assigned to the RAF Search & Rescue team in Anglesey, Wales. He is now Patron on the Mountain Rescue Service (England and Wales).

As well as a career in the military, William is also keen on his charitable work. His mother was very adamant that 'her boys' would grow up to appreciate that there are people less fortunate in the world. As a result, Princess Diana would regularly take Prince William and Prince Harry on visits to her charities such as Centrepoint (a charity which helps homeless people www.centrepoint.org.uk). This was a charity that Princess Diana held in high regard, and Prince William took on its patronage after her death. As well as visiting the charity and helping out, he has also slept rough to highlight the issues of the charity. Further afield, Prince William is Patron of the Tusk Trust (www.tusk.org), which is a conservation charity that attempts to secure a peaceful existence for Africa's wildlife and people. Princes' William and Harry have been involved in a few of their overseas projects. Through his mother he is also a keen supporter of the National Aids Trust (www.nat.org.uk) and the Royal Marsden Hospital. When his mother died, he became a Patron of the Diana, Princess of Wales Memorial Fund.

Catherine Middleton

Known to the British Press as 'Kate', Catherine Middleton will be Prince William's consort and future Queen. She is the oldest of three children and was born at the Royal Berkshire Hospital in Reading, England, on 9 January 1982. This makes her six months older than Prince William. The Middleton family – consisting of father, Michael, mother, Carole, and two siblings, Philippa and James – have lived in Bucklebury, Berkshire, since 1995. When Catherine was small, her parents started a company called Party Pieces, which specialises in selling party supplies by mail order.

Educated at St Andrew's School in Pangbourne, Berkshire, she then attended Downe House, an Independent Girls' School in Thatcham, Berkshire, for a short period before moving onto Marlborough College. Marlbourgh was founded in 1843 for the sons of Church of England Clergy, but is now a co-education Boarding School with about 800 pupils. Catherine was popular and athletic, captaining the school hockey team. At Marlborough, she attained extremely good exam results, two A Levels at 'A' grade and one at 'B' grade, and eleven GCSEs.

Before going off to University, Catherine attended the same Operation Raleigh project in Chile that William had visited just one month before. At St Andrew's University, Catherine studied History of Art – the same course the Prince had started. Unfortunately, like a few

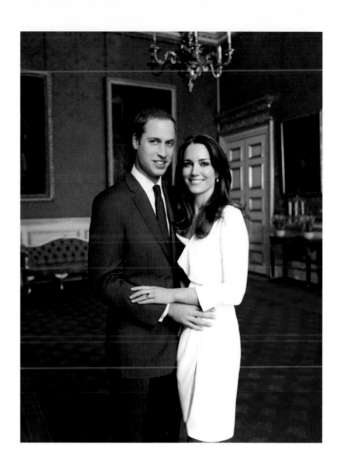

Catherine and William pose for
an official engagement photo at
St James' Palace.

students, Prince William's enthusiasm for his course waned, and it has been speculated that it was Catherine who convinced William to stay at university and pursue another course.

While at University, Catherine and William moved in together. Although insisting they were 'just good friends', they became close and a relationship developed. However, things did not run smoothly. As with dating any member of the Royal Family, Catherine's relationship with the Prince came under intense media scrutiny, and the press hounded her constantly. In February 2006, it was announced that Catherine could have 24-hour security, and this fuelled more media speculation that an engagement was imminent. Unfortunately, no engagement materialised and Catherine did not receive the security.

November 2006 saw Catherine take up a position with the fashion chain Jigsaw as an Accessories Buyer, although this came to an end in autumn 2007. She was pursued by photographers and it became apparent that she could not work as effectively as she wanted to while holding down such a high-profile relationship and under such intense media pressure. After this she decided to look at more flexible jobs, such as photography. She has also worked for her parents in their business 'Party Pieces'.

By April 2007, there was speculation that Catherine and William had split up. The story broke in the UK by *The Sun* newspaper, and the media, including the BBC, reported on it. The newspapers claimed a 'close friend' supplied the story and blamed the break-up on relationship issues. After the Concert for Diana on 1 July 2007, Catherine and the

Prince claimed they were 'just good friends'. However, media speculation was that their relationship had been 'rekindled'. From then on, Catherine became the Prince's companion, accompanying him when he needed a partner.

While holidaying in the Lewa Wildlife Conservancy Kenya in October 2010, Prince William proposed to Catherine, and their engagement was announced on 16 November 2010.

PRINCE CHARLES AND THE DUCHESS OF CORNWALL

The path of true love never runs smooth! No truer words can be said about the relationship between Prince Charles and the Duchess of Cornwall.

Their relationship began back in the 1970s, when Prince Charles was the ultimate catch. His name was linked to many women including Princess Marie Astrid of Luxembourg, Lady Jane Wellesley, and the actress Susan George. At one point he dated Lady Sarah Spencer, sister of his future wife, Lady Diana Spencer. However one name became synonymous with him: Camilla Shand (later Camilla Parker-Bowles).

Charles met Camilla during a Polo match in 1970. Both were keen on horses and were attracted immediately. While Charles wanted to marry her, she was not seen as a suitable future Queen. By 1972, Charles had gone into the armed forces and went overseas for his military service, while Camilla married Andrew Parker-Bowles in July 1973. Camilla had two children from this marriage – Tom and Laura.

On 29 July 1981, Charles married Lady Diana Spencer and had two children, Prince William and Prince Harry. On the surface, Charles and Camilla remained friends, but in 1995, Mrs Parker-Bowles was divorced by her husband on the grounds that she had had a long-term affair with the Prince of Wales.

The tragic death of Diana, Princess of Wales, changed their lives dramatically. After a period of mourning, Charles was free to marry again, and, with Camilla being divorced, it was only a matter of time before their relationship became serious and in the public spotlight. Camilla unofficially accompanied Charles on a few public events and she became a hit. On 10 February 2005, Charles and Camilla announced their engagement. Charles gave his new fiancée a ring, which was a family heirloom.

There were, however, a few challenges associated with the marriage. First was that Camilla and Charles were divorced, so there could not be a Church marriage service in a Church of England church. Then the Queen's permission had to be sought, and this was granted. The civil service was to be conducted at Windsor Castle, but this could not happen as a civil marriage licence would mean opening the castle to the public for weddings. Therefore, the venue was moved to Windsor Guildhall. Then the wedding had to be delayed by a day in order for the Prince to attend the funeral of Pope John Paul II. So it was decided to have a Civil Ceremony, followed by a Church Blessing. Prince Charles was the first member of the Royal Family to be married by civil ceremony.

On Saturday 9 April 2005, Prince Charles married the love of his life. It was a beautiful day, and the bride looked radiant for the Civil Ceremony in an oyster-silk basket-weave coat and a chiffon dress, designed by Robinson Valentine. Her hat was designed by Philip Treacy. Then, for the Blessing at St George's Chapel, she wore a porcelain-blue silk dress with hand-embroidered gold thread work. This was topped with gold-leaf feathers and Swarovski Diamonds.

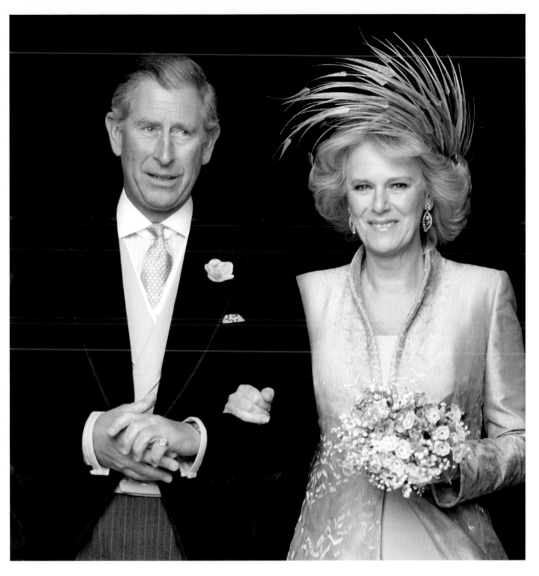

Prince Charles and Camilla after their Civil Ceremony.

The Queen did not attend the civil wedding ceremony because of her position as Head of the Church of England, but she did attend the church blessing and hosted a reception afterwards. The wedding was a huge success. Crowds gathered in the streets of Windsor hoping for a glimpse of the couple. Prince William and Tom Parker-Bowles were witnesses. The wedding rings were made from welsh gold.

Since her wedding, Camilla has used the title of Duchess of Cornwall, and in Scotland, Duchess of Rothesay. She carries out royal duties on her own as well as with the Prince of Wales, and has become a Patron of a number of charities.

PRINCE CHARLES AND LADY DIANA SPENCER

Prince Charles was born on 14 November 1958 to HRH Princess Elizabeth and Philip, Duke of Edinburgh. He is the oldest of four children – Anne, Andrew and Edward. At the time he was born, his grandfather, George VI, was still King. His mother ascended the British throne when he was three, and became Queen when he was four. His parents made the decision that he should attend school, rather than be tutored, so the young prince attended Cheam School in Berkshire, followed by Gordonstoun, in Scotland. During his time at Gordonstoun, he was an exchange student at Timbertop in Australia. After leaving school he went to Cambridge University, initially reading Archaeology and Anthropology, but later changed to History.

After University, he joined the Royal Air Force, then the Navy, and became a qualified helicopter pilot. Around this time, the nation became obsessed about who Charles would marry. He was in his late twenties and settled in a career, and was of the age when he should think of marriage. Quite a few ladies were seen on the Prince's arm – some suitable, some unsuitable. Also there were European princesses to consider as well. After a series of relationships, Prince Charles announced his engagement to Lady Diana Spencer on 24 February 1981.

Diana was a modern woman. She was nineteen, lived with flatmates, had a job and a car. She lived life her way. Suddenly, she was thrust into the Royal Family and she had trouble adapting to the media intrusion in her life. At one point, the press set up shop outside the Kindergarten where she worked, and the staff became so concerned about them frightening the children, that Diana agreed to pose for photographs if they would go away.

Diana was a shy, sweet girl who had had a difficult childhood. Born on 1 July 1961 at Park House, part of the Queen's Sandringham Estate, she was the second youngest of four siblings. She was close to her brother, Charles, and her two older sisters, Sarah and Jane. Following her parents' divorce when she was only eight, her father gained custody of the children and they lived with him at Althrop House. When Diana was sixteen, her father married Raine, Countess of Dartmouth, and daughter of the novelist Barbara Cartland. However, Diana never warmed to her new stepmother.

Diana was educated at Silifield School and Riddlesworth Hall in Norfolk, then at the West Heath Girls' School in Sevenoaks, Kent. Then, she attended finishing school at the Institut Alpin Videmanette in Switzerland. She was never an academic pupil, but she did excel in piano, swimming and diving. Her ambition was to become a ballerina, but her height prevented her from carrying on. On her eighteenth birthday, she bought a flat with money inherited from a relative. There she lived with three flatmates until her marriage in 1981. Her jobs included working with children as she loved to be around them, and so she became a dance instructor with a youth group, a nanny, and then a playgroup assistant.

Charles had known Diana for many years. He had dated her sister, Lady Sarah Spencer when Diana was a teenager, and Diana had known Prince Andrew since they were children. In fact, before Charles and Diana became an item, there was speculation about whether Diana would marry Prince Andrew. However, Press speculation started about Charles and Diana in the summer of 1980 when Diana watch Charles play in a Polo match. Various invitations to join the royal family followed and, once approved by the Queen, Charles proposed to Diana over dinner at the beginning of February 1981.

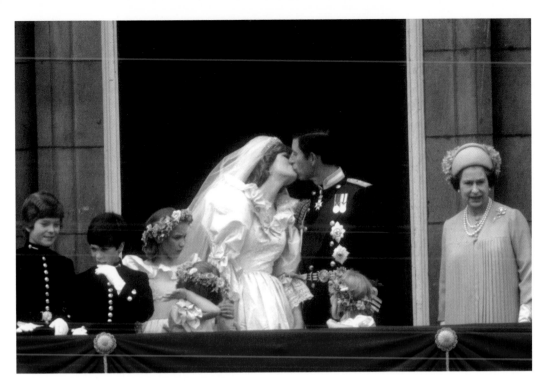

The Famous Kiss! (Library of Congress)

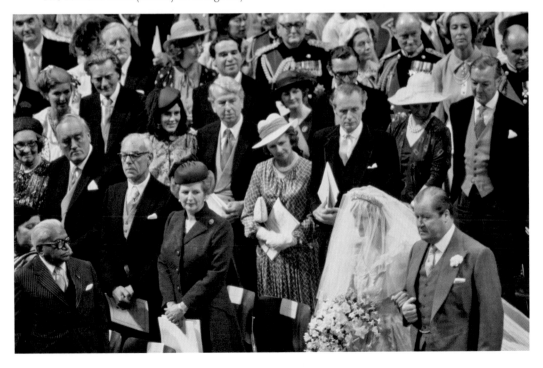

Amongst the guests at Charles and Diana's wedding were Prime Ministers and Heads of State. (Library of Congress)

On 24 February 1981, Charles and Diana walked onto the lawn at Buckingham Palace, Diana was wearing a blue suit and on her finger was a ring with a huge sapphire surrounded by fourteen diamonds. The ring was made by the Royal Jewellers, Garrard. The nineteen-year-old Lady Diana Spencer looked happy on the arm of her prince.

The Wedding

The date was set for 29 July 1981. It was a glorious day – very hot and the sun was shining. Masses of people lined the streets to catch a glimpse of the royal party travelling to and from St Paul's Cathedral. Millions more watched the event on television, with hundreds of millions watching worldwide.

It was a 'fairytale wedding'. The bride left Clarence House in the Glass Coach with her father, Earl Spencer. After arriving at St Paul's Cathedral, the public caught their first glimpse of the long-awaited wedding dress. The dress designers, David and Elizabeth Emmanuel, had kept all the details of the dress under complete secrecy. The twenty-year-old Diana emerged from the Glass Coach in an ivory, pure silk, taffeta and antique lace dress. The silk came from Lullingstone Silk Farm, the only silk farm in Britain; and the lace was Carrickmacross Lace, which once belonged to Queen Mary. The train of the dress stretched 25 feet and was detachable. The dress had thousands of mother-of-pearl sequins and pearls and cost £9,000 at the time.

For accessories, she wore a Spencer family tiara and an eight-foot-long veil. It was reported that the tiara gave her a headache. Her shoes were made by Clive Shilton and had 24-carat gold trim on the low wooden heels. They were trimmed with an embroidered lattice pattern.

Diana's bouquet was a huge array of flowers, such as gardenias, white Odontoglossum orchids and Stephanotis, with ivy and tradescantia leaves. There were three versions of the bouquet, all designed by Longmans Limited of London. They were used at different stages of the wedding. The first was displayed in Longman's shop after use in rehearsals, the second was used for the actual wedding and the third for formal photographs. Versions two and three were placed on the Tomb of the Unknown Soldier after the wedding.

Prince Charles had 'supporters' rather than best men. His supporters were Prince Andrew and Prince Edward. Diana's bridesmaids were: Lady Sarah Armstrong Jones, daughter of Princess Margaret and Lord Snowdon; India Hicks, grand-daughter of Earl Mountbatten of Burma; Sarah-Jane Gaselee, daughter of Nick Gaselee, who trained Prince Charles to become a jump jockey; Catherine Cameron, grand-daughter of the Marquess of Lothian; and Clementine Hambro, great-granddaughter of Sir Winston Churchill. The bridesmaids all wore dresses, which were very similar to the wedding gown. However, these were trimmed with gold velvet sashes. The pageboys were Lord Nicholas Windsor and Edward van Cutsem.

Diana made a mistake in her wedding vows by mixing up Charles' names. She also deliberately left out the word 'obey' from her vows. This caused quite a sensation at the time. Following this it became fashionable to leave the word out of wedding vows. After the three minute walk down the aisle to the strains of Jerimiah Clarke's Trumpet Voluntary, Diana met her Prince who was dressed in his Naval Commander's uniform. The couple wanted it to be a musical occasion, so the hymns included Sir Cecil Spring-Rice's 'I vow to Thee,

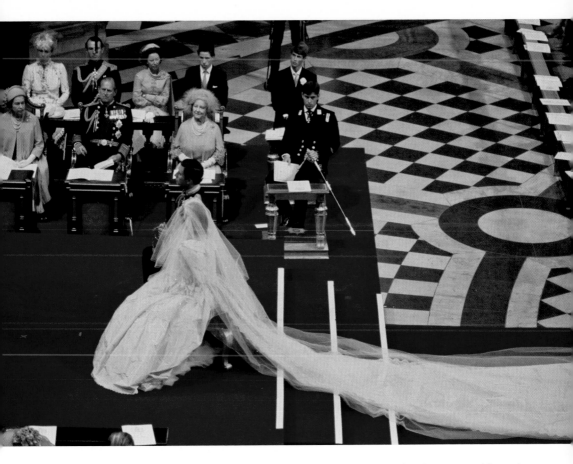

Charles and Diana with members of the both families (Earl Spencer's head is just visible at the bottom of the photo) during the wedding ceremony. (Library of Congress)

My Country' (music by Gustav Holst), and 'Christ Is Made The Sure Foundation' by Purcell. Dame Kiri te Kanawa sang 'Let the Bright Seraphim', while 'Let Their Celestial Concerts All Unite' was sung by the Bach Choir. When the couple proceeded back down the aisle, Elgar's 'Pomp and Circumstance No 4' joyfully played.

After the ceremony, the couple returned to Buckingham Palace in an open-topped landau (carriage). The couple appeared on the Buckingham Palace balcony where the famous kiss took place, and there was also a wedding breakfast for 120 specially-invited guests.

After the festivities, the couple were driven to Waterloo Station (and Princes Andrew and Edward put a 'just married' sign on the back of the landau!). From there they caught the Royal Train to Romsey in Hampshire, where they spent a night at the late Earl Mountbatten's home, Broadlands, before flying out to Gibraltar for a Mediterranean Cruise on the Royal Yacht *Britannia*. Then it was on to Balmoral, in Scotland where the Queen, Prince Philip and other members of the Royal Family joined them for a break.

PRINCESS ELIZABETH TO PHILIP MOUNTBATTEN

Elizabeth

At the time of her birth, Princess Elizabeth was not expected to ascend the throne. Her Grandfather was on the throne, and her uncle, Edward, Prince of Wales, was expected to marry, become King, and produce an heir. So, in the beginning, the young Princess Elizabeth had a fairly normal up-bringing for an aristocratic child of her time. She was born on 21 April 1926, to the Duke and Duchess of York and brought up in the family's home at 145 Piccadilly. The Duke and Duchess were determined that Elizabeth and her sister Margaret would have a stable upbringing and be brought up to appreciate the privileges they had and not be spoilt. Unfortunately, during her first year, her mother and father had to make an official visit to Australia, leaving Elizabeth in the capable hands of her grandparents – the King and Queen – and her nanny, Clara Knight.

As the young princess learned to speak, she called herself 'Lillibet'. Princess Elizabeth and her sister were educated by private tutors, as the new King Edward VIII decided that he did not want the young princesses to be educated with common people. This dashed the hopes of her parents, who wanted her to attend school. However, both Princess Elizabeth and Princess Margaret were members of the Girl Guide Association.

However, in 1936, Princess Elizabeth's life changed drastically, when the news of King Edward VIII's relationship with Wallis Simpson emerged and his subsequent abdication in December of that year. Her father became Heir to the Throne and this meant the Princess was now in line to become Queen. Not only did she take instruction from Palace officials about matters relating to the state, but she also attended classes at Eton College to study constitutional history.

As war was announced, Princess Elizabeth started to take on more royal duties. She became Patron of numerous charities and made royal visits with her parents. When her father was not available, she also undertook some of his official engagements as Head of State. She also insisted in doing her part in the war and joined the Auxiliary Territorial Services as a Second Subaltern, eventually becoming a qualified driver. After the war, Princess Elizabeth returned to her official duties. In 1947, she travelled to South Africa on her first official overseas visit. Although she had known Lieutenant Philip Mountbatten since she was a teenager, the relationship had not been in the spotlight. However, this dashing young man was to become her bedrock.

Philip Mountbatten

On 10 June 1921, at the Villa Mon Repos in Corfu, Prince Philip was born into the Danish and Greek royal families. It seems really strange that a Royal Family member of two countries which are geographically so distant can share the same title. This is because many members of the deposed Greek royal family are descendents of George I of Greece, who was a Danish Prince. Until 1953, Denmark's hereditary line of succession was through this line, so members of the Greek Royal Family hold the title Prince or Princess of Denmark. It's all very complicated!

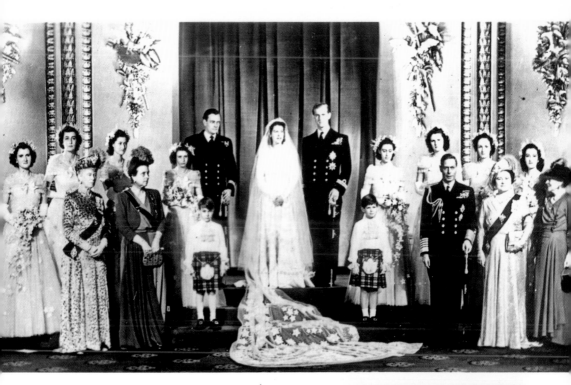

Above: Members of the immediate
family and wedding party pose
with Princess Elizabeth and Philip
Mountbatten for the official
wedding photographs.

Right: Elizabeth and Philip after
their wedding.

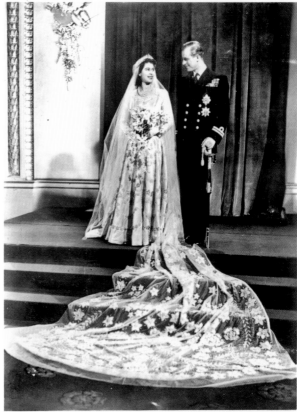

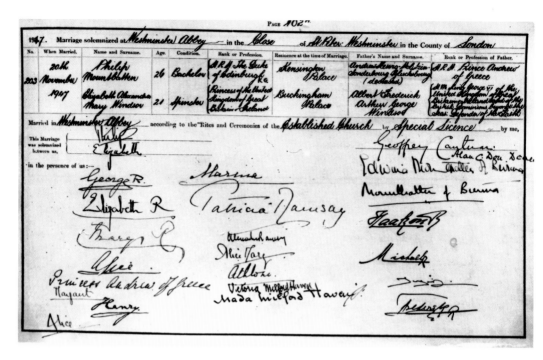

Elizabeth and Philip's register entry for their wedding.

Prince Philip was the youngest child of Prince Andrew of Greece and Denmark and Princess Alice of Battenberg. He has four older sisters – Margarita, Theodora, Cecilie and Sophie. His maternal grandfather, Louis of Battenberg, had moved to Britain and became a naturalized British Citizen. After a distinguished naval career, he renounced his German titles, and took the surname Mountbatten.

Philip's family were exiled from Greece when he was young when the Greco-Turkish War forced King Constantine I of Greece to abdicate. His family fled the country on HMS *Calypso*. Settling in France, he was first educated at the American School, then sent to Cheam School, Schule Schloss Salem in Germany, and then finished school at Gordonstoun in Scotland.

At the start of the Second World War, Prince Philip joined the Royal Navy and saw war service in the Indian Ocean, Pacific Ocean and the Mediterranean sea. It was even rumoured that during his service he stoked the boilers for RMS *Empress of Russia* – a troopship! During his naval career he was promoted to First Lieutenant.

However, back to 1939, while at the Royal Naval College in Dartmouth, Prince Philip was asked to accompany Princesses Elizabeth and Margaret Rose around the college during a visit by their parents.

After this, Princess Elizabeth and Prince Philip started writing to each other as friends as Elizabeth was still too young to think about a relationship, but a romance eventually blossomed. Although Philip asked the King for Elizabeth's hand in marriage in 1946, their engagement was delayed due to the royal protocol that Philip had to renounce his allegiance to the Greek crown and his Greek Orthodox religion and become a naturalised British citizen. Philip then took the name Mountbatten. The engagement was announced in July 1947.

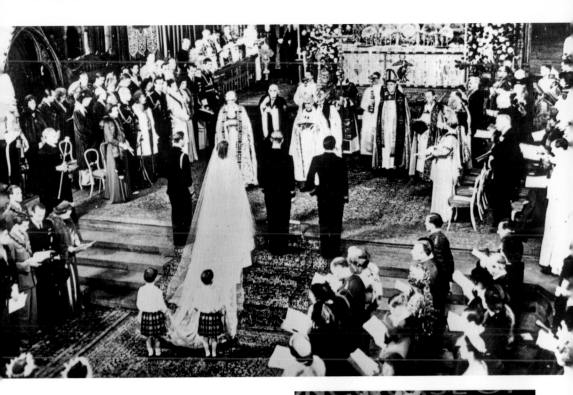

Above: The wedding ceremony of Princess Elizabeth and Philip Mountbatten.

Right: Princess Elizabeth's wedding bouquet was placed on the Tomb of the Unknown Soldier. This has been a tradition with royal brides since just after World War One.

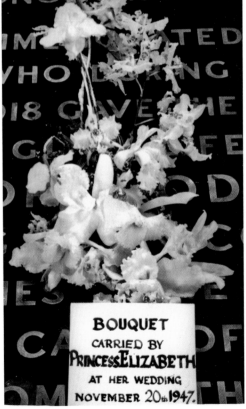

BOUQUET
CARRIED BY
PrincessELIZABETH
AT HER WEDDING
NOVEMBER 20th 1947.

The Wedding

Princess Elizabeth and Prince Philip were married on 20 November 1947. This was a major event as Britain had been at war and was slowly recovering. This event would lift the nation's spirits and symbolise hope for the future. The wedding took place at Westminster Abbey, where more than 2,000 guests attended. There were eight bridesmaids and two page-boys. The wedding was officiated by the Archbishops of Canterbury and York. Unfortunately, some of the Duke of Edinburgh's relatives were unable to attend – including his sisters – as they had some connections with Germany.

As Britain had just emerged from the Second World War, rationing was still in force. Elizabeth had to save up ration cards for the material for her dress and the nation helped out by sending clothing coupons. The dress was designed by Norman Hartnell, and was made of ivory duchess satin. It was decorated with 10,000 white pearls, and had flower symbols from Commonwealth lands, such as Scottish thistles and Canadian maple leaves. Her bridal bouquet had a sprig of myrtle from a bush planted from Queen Victoria's bouquet. The day after the wedding, the bouquet was laid on the Tomb of the Unknown Soldier.

Returning to Buckingham Palace, the Queen and Prince Philip appeared on the balcony to the delight of the crowds below. A Wedding Breakfast was held for them in the Ball Supper Room, and because there was still rationing in Britain, their wedding cake was made from ingredients that were sent over by the Australian Girl Guides.

After the wedding, Prince Philip and Princess Elizabeth left for honeymoon at Broadlands, and then onto Birkhill at Balmoral. On their return, Prince Philip returned to the navy and the young couple were stationed in London and Malta.

EDWARD VIII AND MRS WALLIS SIMPSON

Although, technically, not a 'royal' wedding, the relationship between Edward VIII and Wallis Simpson cannot be overlooked in a book about royal weddings. This was the relationship and wedding that, in recent history, changed our monarchy – it made a king abdicate for the woman that he loved.

Edward

Edward was brought up to be King. He was charismatic and charming, and had a dashing beauty about him. Edward knew from childhood that he was destined to become King. He was the first child to George V and Mary of Teck. His other siblings were Albert (later George VI), Mary, The Princess Royal, Prince Henry, Prince George and Prince John. Born during the reign of Queen Victoria, his father ascended the throne when Edward was six. Edward and his siblings were brought up by nannies and educated by private tutors. After this, he moved on to the Osborne Naval College for two years – which he did not enjoy – then onto the Royal Naval College at Dartmouth. After that he went into the Navy. However, just a month after his sixteenth birthday on 23 June 1910, he was made Prince of Wales after his father became King and had to withdraw from college to undertake preparations for his future career as King. He did a stint at Magdalen College, Oxford, but left prematurely.

As the First World War broke out, Edward joined the Grenadier Guards and saw service in the trenches; although the Secretary of State at the time refused to let him serve on the front

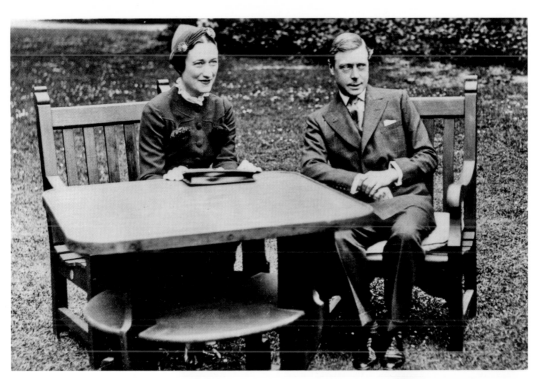

Above: The Duke and Duchess of Windsor. After the King's abdication, the couple lived in France. This view shows them just before their wedding.

Right: Edward and Wallis at home in the West Indies.

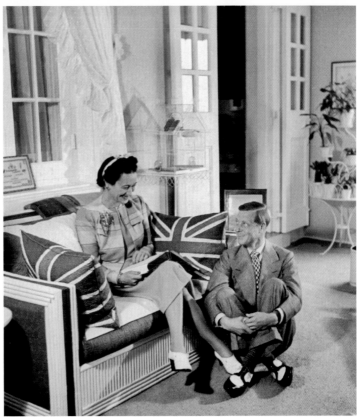

line in case he was captured. His popularity with the people increased due to his willingness fight for his country. After the war, the Prince of Wales undertook tours of the Empire and visited many places at home and abroad. One of these trips was to Australia on HMS *Renown* – my grandfather was a stoker on board at the time of this trip and brought my great-aunt a brooch with the Australian map, a Wishbone and Kookaburra on it. This was in turn handed down to me. During his travels, Edward also was a regular on the world's great ocean liners such as RMS *Olympic* and RMS *Queen Mary*. As he was seen around town and in glamorous places, Edward was well-photographed and became a fashion trend-setter.

However, there was another side to the Prince of Wales. He was unmarried and could not settle down. He had affairs with married women, including Freda Dudley Ward – a textile heiress – and Lady Furness. It was she who introduced Edward to Mrs Wallis Simpson.

Wallis Simpson

Born Bessie Wallis Warfield in 1896 in Blue Ridge Summit, Pennsylvania, she was the only child of Teackle Wallis Warfield and Alice Montague. However, her father died of tuberculosis when she was a baby and she and her mother were taken care of by her wealthy uncle, Solomon Davies Warfield. Shortly after, her aunt Bessie was widowed and Wallis and her mother moved into her house in Baltimore. In 1908, Wallis' mother married Democratic Party chief, John Freeman Rasin Jr. Wallis attended the private school, Oldfields School, during her early life. Her uncle paid for them. She made friends with heiresses, industrialists and Senators' daughters.

Her first husband was Earl Winfield Spencer Jr. She met him while visiting her cousin Corinne in Florida. He was a US Navy pilot. They were married on 8 November 1916 in Baltimore. Win and Wallis moved to San Diego, then onto Washington DC. While her husband was posted overseas, she had an affair with an Argentinian Diplomat, Felipe Espil. Another of Wallis' affairs was rumoured to be with Count Galeazzo Ciano, who became Mussolini's son-in-law. She and her husband split in 1925 and were divorced in 1927.

However, Wallis did not let the grass grow under her feet. By the time her divorce came through, she was already linked with Ernest Simpson, who was in shipping. After divorcing his wife, he married Wallis on 21 July 1928 in London. As the couple were affluent, they met many aristocrats and titled people. She became friends with Lady Furness, who was the Prince of Wales' current mistress. While moving in the same circles, Wallis caught Edward's eye and the pair soon started an affair. At that point, Wallis' marriage to Ernest Simpson was disintegrating. His fortune had diminished and the couple were living beyond their income.

As the relationship between Edward and Wallis flourished, concerns were being raised about his dependence on her. She was unacceptable as Queen because she was a divorcee, his mother and father could not accept her as a member of the Court, and the affair was affecting his work.

In 1936, George V died and Edward became Britain's next king. Unfortunately, his relationship with Wallis was unacceptable to the Government and to Court. Also, the Church of England would not allow him to marry her as her ex-spouses were still living.

After her Decree Nisi was granted in October 1936, Wallis fled to Cannes, France, after the scandalous affair was made public in Britain. The King was given an ultimatum – Wallis or his Country. He chose Wallis. On 10 December 1936, Edward signed the Instrument of Abdication. Then, on 11 December, broadcast his abdication speech to the nation and left Britain.

The couple were reunited at the Chateau de Cande in France in May 1937. Edward

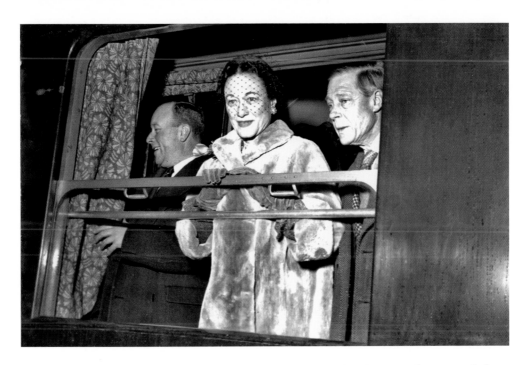

Edward and Wallis travelling in style. Wallis was renowned for her chic up-to-the-minute fashion sense. Here, they have just arrived at Cherbourg on the Boat Train, ready to catch the *Queen Mary* in 1952.

gave her a 19.77 carat emerald, accompanied by diamonds. They were married one month later on 3 June 1937 – King George V's birthday. The Royal Family did not approve of the wedding and did not attend. Wallis was not accepted into royal circles nor was she allowed to use the title of Her Royal Highness.

The Wedding

The chateau had been beautifully decorated for the wedding with pink and white peonies. Sixteen guests, including Wallis' Aunt 'Bessie', attended the ceremonies. The first ceremony was a French civil ceremony, then a religious blessing was performed by the Reverend Robert Jardine. He was an Episcopalian Minister from Yorkshire. They could not have a Church of England blessing because the Church did not approve of their marriage.

Wallis's wedding attire consisted of a blue, full-length cocktail dress in silk crepe fabric by the designer Mainbocher. This also came with a fitted jacket and gloves. A hat with pink and blue feathers had been designed by Caroline Reboux in the style of a cloche hat. Her blue shoes were made of suede and designed by Georgette of Paris. She borrowed a handkerchief from her aunt. Her trousseau was made up of more than sixty pieces by famous French designers such as Dior.

The couple's wedding reception was a meal of lobster, chicken *a la* King, salad and to finish, strawberries and cream. They had a six-tier wedding.

For their honeymoon, they went to Venice and Milan, then Austria, then onto the Schloss Wasserleonburg in Germany. As Wallis had a fear of flying – after seeing two air accidents when she was first married to Earl Winfield Spencer – she preferred to travel by land and sea.

PRINCE ALBERT AND LADY ELIZABETH BOWES-LYON

Queen Elizabeth, The Queen Mother, was a tower of strength to her husband before and during his reign. Her support meant that a man who never expected to be King, became one of the most loved British monarchs.

Elizabeth

Elizabeth was born on 4 August 1900 in London. Her father, the Scottish Aristocrat, Lord Glamis and his wife Cecilia had ten children. Elizabeth was the second youngest. She spent her young life between the family's country estate at St Paul's Waldenbury in Hertfordshire, and Glamis Castle in Scotland. When she was four, her grandfather died and her parents became the Earl and Countess of Strathmore.

Most of her schooling until the age of eight was by Governesses, then she went to a private academy in Sloane Street. Her mother removed her and then employed Kathie Kuebler as her tutor. Unfortunately, at the start of the First World War, Miss Kuebler left the family's employment.

Turning fourteen at the beginning of the First World War, Elizabeth helped recuperate wounded soldiers at the family home at Glamis. This meant that the young Elizabeth had to learn to talk to people from all walks of life. She lost her brother Fergus in the war, and another brother Michael was captured and sent to a prisoner of war camp.

At the end of the war, Elizabeth returned to the aristocratic life of a young debutante. Life was a whirl of society balls and events such as Ascot. At these events she came across a young man who was to change her life, Prince Albert (later George VI).

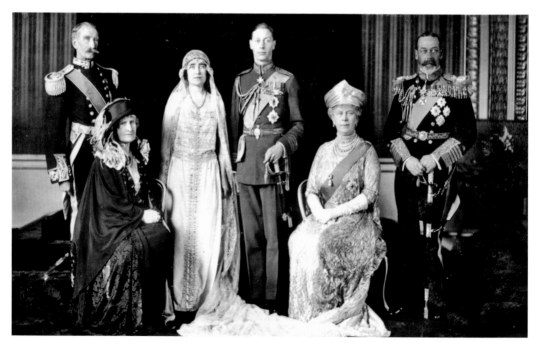

Prince Albert and his new wife with their parents.

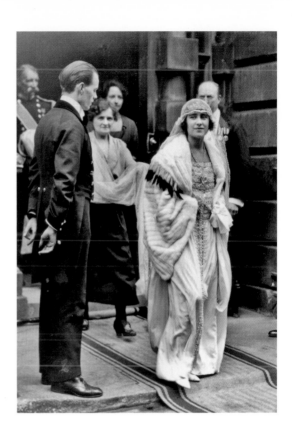

Lady Elizabeth Bowes-Lyon leaves her house for her wedding.

Bertie, as he was known, became entranced by the young Elizabeth. Although Elizabeth came from an aristocratic background, technically she was a 'commoner'. This was a marriage of love rather than a marriage of alliance between two nations. It was said that he had proposed to her three times when she had accepted on 18 January 1923. This was probably because of advice she had been given to avoid entanglements with royalty at all costs. However, the engagement did go ahead and Bertie gave Elizabeth a sapphire engagement ring. This was not a long engagement and the wedding date was set for April 1923.

Bertie

Prince Albert, known as Bertie, was the second son of Prince George, Duke of York. As he was the second son, he had no aspirations of taking over the throne and, being a shy man, did not court publicity. He left that to his older brother Prince Edward.

Bertie was born at York Cottage, on the Sandringham Estate in Norfolk. His father was the great-grandson of Queen Victoria, and his mother was the daughter of the Duke and Duchess of Teck. He was named Albert as he was born on the anniversary of the death of Queen Victoria's husband, Albert.

In childhood, Bertie was often ill, suffering from stomach and knee problems. He was brought up by nannies and governesses, as was the norm in this time for royalty. His stammer started in childhood, and it was thought that he was naturally left-handed, even though he wrote with his right. At the time, it was thought to be sinister if a child wrote with their left hand and it was often physically discouraged.

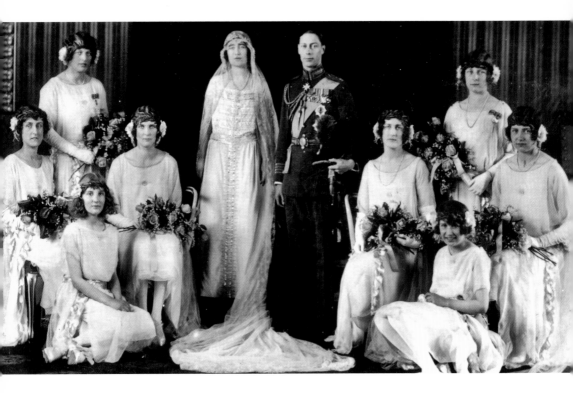

Elizabeth and Bertie with their bridesmaids.

Even after his grandfather's succession to the throne in 1901, Bertie was still only third in line to the throne. While still being close to the throne, he was far enough removed that he could embark on other things rather than concentrating on being king. Therefore, it was thought that a career in the armed services would be a good move. Unfortunately it wasn't. At the Royal Naval College, Osborne, in his final exam, Bertie came bottom of the class. However, he did go on to the Royal Naval College in Dartmouth. He saw service in the First World War in the Battle of Jutland, but was taken out of action because of a duodenal ulcer. Then he went to the Royal Naval Air Service at Cranwell, but then transferred to the Royal Air Force training centre there.

Bertie did go to Trinity College, Cambridge for a year in 1919, where he read history, economics and civics. After becoming Duke of York, he started to take on royal duties for his father. He became interested in industry and working conditions, and became President of the Industrial Society. This society provided advice, consultancy and research on the future of work, and improving working life.

It was around this time – 1920 – that he met Lady Elizabeth Bowes-Lyon, and, after rejecting two marriage proposals, she finally accepted.

The Wedding

The wedding took place on 26 April 1923 at Westminster Abbey. Elizabeth's dress was designed by Madame Handley Seymour, a former Court dressmaker to Queen Mary. It was a 'flapper style' dropped-waist, full-length dress with a train. Her headdress was worn in a very modern way for the time – low over the brow, like a cloche hat. Her bouquet was of white

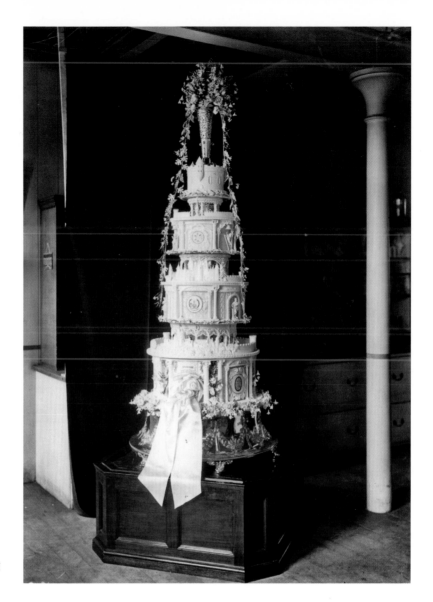

The McVitie &
Price Wedding
Cake, weighing
800 pounds!

lilies. Prince Albert wore his RAF Group Captain's uniform. There were eight bridesmaids, including cousins of the groom and nieces of the bride.

The BBC wished to record the wedding, but this was not allowed by the Church as it could not be guaranteed that it would be heard only in respectful places. However, it was the first royal wedding to be filmed.

Back at Buckingham Palace, the wedding breakfast consisted of Consomme a la Windsor, Supremes de Saumon Reine Mary, Coteletters d'Agneau Prince Albert, Chapons a la Strathmore and Fraises Duchesse Elizabeth. Many wedding cakes were decorated, including one by McVitie & Price ,which weighed 800 pounds!

The honeymoon consisted of time spent at Polesden Lacey, Surrey, and at Glamis Castle, where Elizabeth contracted whooping cough. Not a good start to a honeymoon.

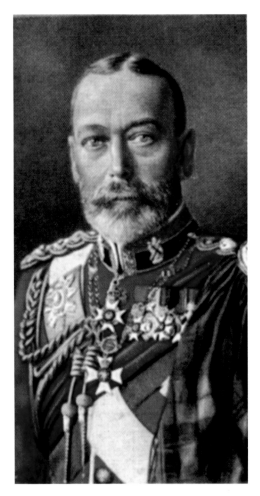
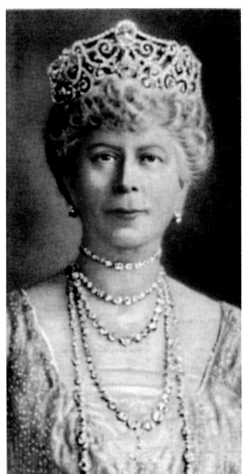

King George V and Queen Mary.

GEORGE V AND PRINCESS MARY OF TECK

This was the last major royal marriage that was arranged as a strategic alliance between countries, rather than for love. However, it was under the most tragic circumstances that brought them together.

George

George was the second son of Prince Albert Edward, Prince of Wales, and his wife Alexandra, Princess of Wales. He was born on 3 June 1865 at Marlborough House in London. His mother was a member of the Danish Royal Family. At the time, an heir had already been born, so there was no expectation that he would ascend to the throne. It was his brother, Prince Albert, who would take over.

The boys were tutored by John Neale Dalton for fourteen years. He was chaplain to Queen Victoria, and a graduate of Clare College, Cambridge. Both boys did not excel academically. George was motivated to learn, but Eddy (Prince Albert) was not. The boys were eventually

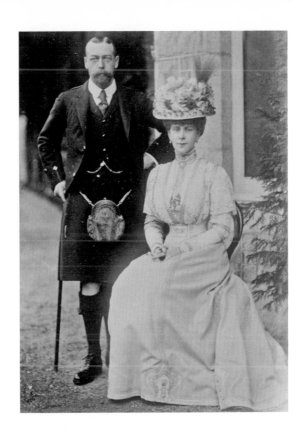

King George V and Queen Mary when they were the Prince and Princess of Wales.

sent to join HMS *Britannia* and Dalton went with them to act as their guardian. Then, he moved to HMS *Bacchante*. While Eddy left the Navy to pursue a place at Cambridge University, George remained. He worked his way up and commanded HMS *Melampus* during her commissioning and sea trials.

While on his naval duties in Malta, he fell in love with Marie of Edinburgh. Unfortunately, due to both mothers resenting each other, George and Marie's relationship came to an end.

In 1891, the engagement was announced for his brother, Eddy, to marry a distant relative, Princess Victoria Mary of Teck – known as May. However, six weeks after the engagement was announced, Eddy fell ill from pneumonia, and died. The double-edged sword of grief and Queen Victoria still thinking May was a suitable candidate as a consort brought the young couple together. George proposed to May a year after his brother's death and they married.

Princess Victoria Mary of Teck

Princess Mary (May) was a great grand-daughter of King George III. Her mother Princess Mary Adelaide of Cambridge married Francis, Duke of Teck. May was born at Kensington Palace in London and was the oldest of four children.

May had known Princes Albert and George since they were children as they played together. Unlike her brothers, May was home schooled by her mother and governesses – her brothers went to boarding school. Her mother insisted that May assist her with charitable causes, and she spent time visiting these charities. May spent a lot of time abroad visiting

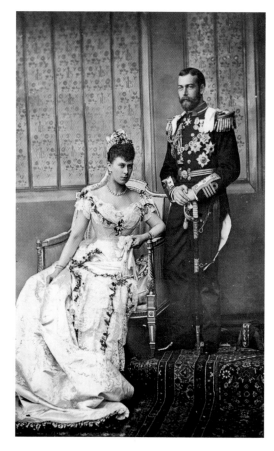

Above: Princess Mary of Wales

Left: Prince George and Mary.

relatives too because her family was not wealthy and this was seen as a way to economise. As she grew up, she helped her mother organise social events.

Queen Victoria decided that May was a suitable marriage choice for her oldest son, Prince Albert. The couple became engaged, then tragically Albert died. A year after this Prince George proposed and she accepted.

The Wedding

The wedding took place on 6 July 1893 at the Chapel Royal, St James' Palace. On the morning of the wedding, Prince George caught a glimpse of his bride, and gave a low bow to her. The royal procession travelled from Buckingham Palace to the Chapel Royal in state landaus. Along the route, large crowds cheered as this was a major event.

May's wedding dress was made of silver and white brocade, trimmed with orange blossom and Honiton lace. Made by Linton & Curtis of London, it was embroidered with a thistle, rose and shamrock, and a train. Her veil was the same one her mother had worn on her wedding day. King Edward gave her a gift of a diamond rivière necklace. May had ten bridesmaids, all cousins or sisters of Prince George. George wore his Naval Captain's uniform. The service was mainly performed by the Archbishop of Canterbury, although at least two Bishops assisted him with the service. The couple honeymooned at Sandringham, Norfolk.

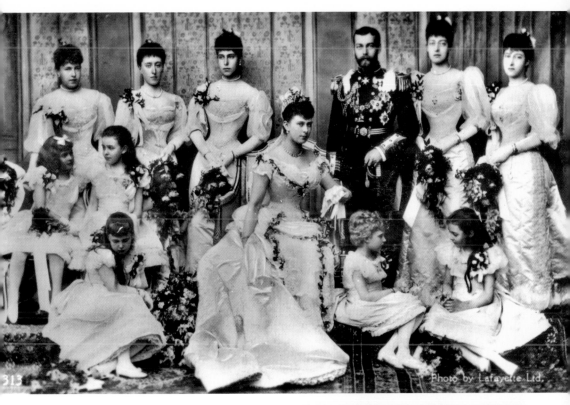

Above: The Wedding portrait of Prince George and Mary with ten bridesmaids.

Right: Mary's dress was made of Silver and White brocade, trimmed with orange blossom and Honiton lace.

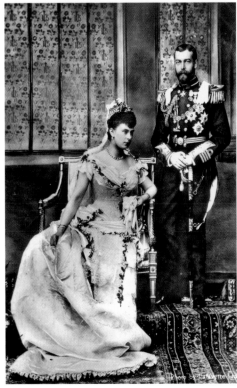

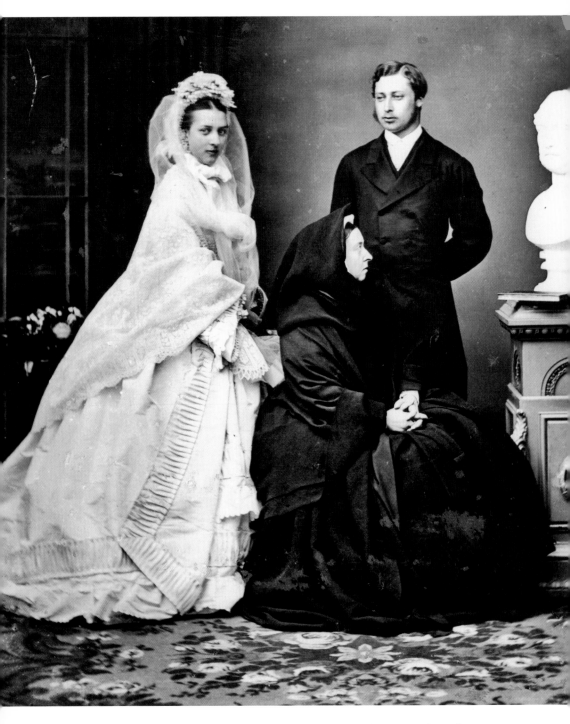

Above: The Prince and Princess of Wales – later Edward VII and Princess Alexandra.

Opposite, left: Edward VII as Prince of Wales.

Opposite, right: Edward VII in his Coronation robes.

EDWARD VII AND PRINCESS ALEXANDRA

Edward was the son of Queen Victoria. In many ways he was unfortunate because his mother was on the throne for sixty-four years, and for a long period he was the King in waiting. Then just as he acquired the throne, his reign was cut short. In all, he ruled for just ten years.

Edward

Edward was the oldest child of Queen Victoria and Prince Albert's nine children. He was born at Buckingham Palace on 9 November 1841. At his christening he was given the names Albert Edward. When Edward was a month old, he was given the title of Prince of Wales, in addition to his birth titles of Duke of Cornwall and Duke of Rothesay.

Prince Albert devised an education for the young Edward that would prepare him for his future as King. He had several tutors, but he was not academically gifted. He studied at Edinburgh, Oxford and Cambridge Universities. He found freedom from his parents and he found that while he did not excel at his subject, he enjoyed studying and passed the subjects. After leaving university, Edward then went on a four-month tour to North America and Canada. This tour was a great success and produced many diplomatic ties between Britain and the Americas.

Edward returned, and was sent to Germany. He thought it was a way of discouraging him from a career in the Army, but it was actually to meet Princess Alexandra of Denmark. This was engineered by Queen Victoria and executed by her daughter, The Crown Princess of Prussia. Both Edward and Alexandra got on well and plans were made for a forthcoming marriage.

 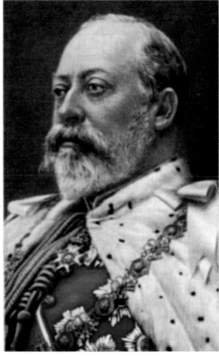

However, a blight was on the horizon. Edward had an eye for the ladies (later on in his marriage he was linked to many mistresses, including actresses Lillie Langtry and Sarah Bernhardt, Lady Randolph Churchill and Alice Keppel). This was to be his one major downfall. Edward was reprimanded by his father for his indiscretion with actress Nellie Clifton. Shortly after, on 14 December 1861, his father died. Queen Victoria never really forgave Edward for his actions. Soon after his father's death, he was sent on a tour of the Middle East. When he came home, his engagement was announced to Princess Alexandra of Denmark.

Alexandra

While Alexandra of Denmark was born into Danish royalty, her family were not wealthy. Her father, Christian IX of Denmark, at the time of her birth, had an army commission and the family lived off that. Also, they lived in a 'grace and favour' property, The Yellow Palace.

Christian had no direct claim on any throne. However, on his mother's side, he was related to Frederick V of Denmark and George II of Britain. He became heir presumptive of the Danish throne after Frederick VII remained childless. After becoming King, he insisted that four of his children marry Kings or Queens from other countries as a strategic alliance with other nations.

The family moved to Bernstorff Palace. They did not take part in Court life, and as they only had a modest income, were frugal in the way that they lived.

Alexandra was not the first choice as wife for Edward. As Denmark had been fighting the Prussians over Schleswig-Holstein, and the British Royal Family had links with the Germans, Alexandra was not deemed a satisfactory match. But they could not find anyone else which met their criteria, so she was chosen.

Alexandra travelled from Denmark to England for her wedding and arrived at Gravesend, Kent on 7 March 1863 on board the Royal Yacht *Victoria and Albert* (II).

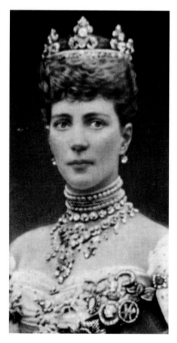

Princess Alexandra of Denmark.

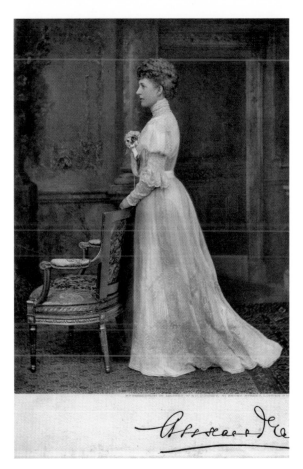

Right: Princess Alexandra.

Below: The Royal Yacht *Victoria & Albert* (II), which brought Princess Alexandra to Britain from Denmark.

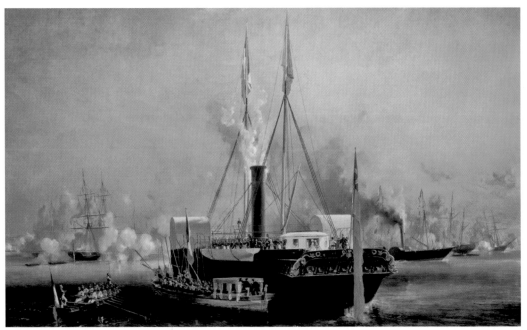

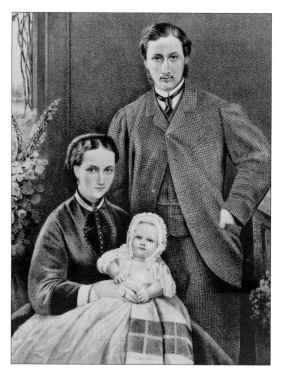

The Prince and Princess of Wales with their new baby.

NOTICE.

THERE WILL BE

NO DELIVERY

OF LETTERS BY THE

LONDON DISTRICT POST

IN THE AFTERNOON OF

Tuesday, the 10th March, 1863,

THE DAY APPOINTED FOR THE

MARRIAGE

OF HIS ROYAL HIGHNESS THE

PRINCE OF WALES.

Letters for the Night Mails will be collected from the Town Pillar Boxes at 5 P.M., and from the Town Receiving Houses at 5.30. P.M., but there will be no Collection, either from the Pillar Boxes or the Receiving Houses, after the hours named.

Letters to be forwarded by the *Morning Mails* on Wednesday, the 11th March, must be posted either at the Head District Offices, the Branch Offices at Lombard Street and Charing Cross, or in the Town Pillar Letter Boxes, as there will be no Collection for such Mails from any Town Receiving House.

There will be no despatch of Mid-day Mails from London to the Provinces on Tuesday.

No Money Order business will be transacted either in London, or at Places within the Twelve Mile Circle, after 12 o'Clock. Noon

Circulation Department,
 General Post Office,
 March. 1863.

W. BOKENHAM,
Controller.

G 1000 2|63

On the day of the wedding, mail deliveries were cancelled.

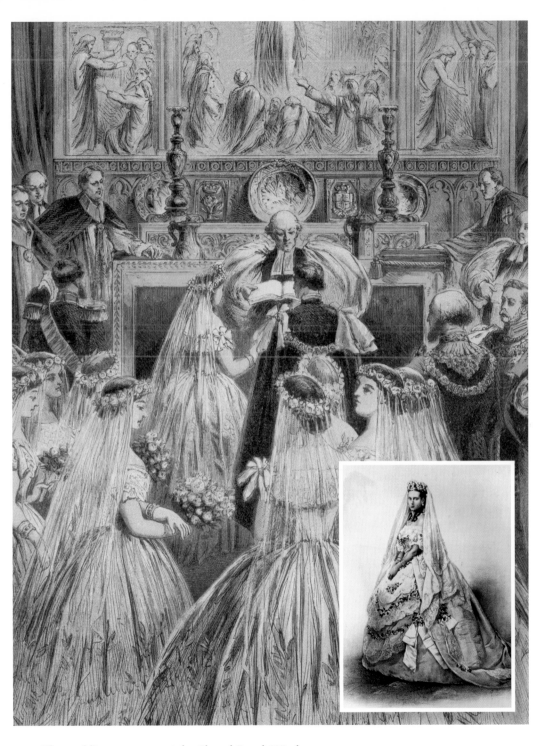

The wedding ceremony at the Chapel Royal, Windsor.

Inset: Princess Alexandra in her wedding dress. The dress was white satin with orange blossom and myrtle.

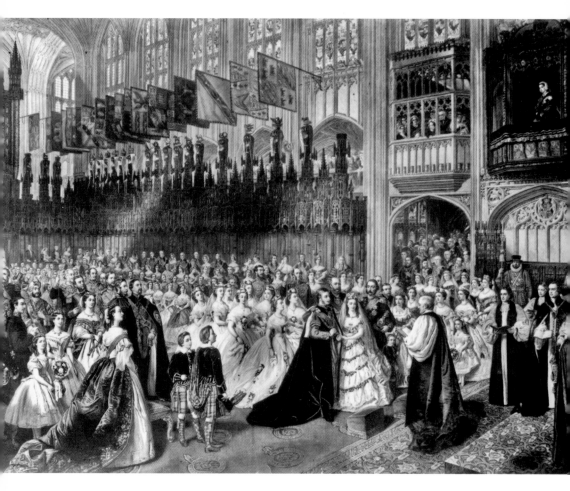

Surrounded by bridesmaids and page boys, the happy couple are joined in matrimony.

The Wedding

The wedding took place on 10 March 1863 at St George's Chapel in Windsor Castle. Scepticism surrounded the choice of venue. It was too small and isolated for many people to attend.

Princess Alexandra's dress had a full skirt and was off-the-shoulder with short lace sleeves. The dress was of white satin and had garlands of myrtle and orange blossom. She had a long silver train and had Honiton lace on the sleeves. Originally, she had been sent a dress by King Leopold of Belgium which included Brussels Lace, but Queen Victoria sent it back and ordered an English dress instead. The Prince was resplendent in his Army General's uniform with his Order of the Garter mantle. Eight bridesmaids attended the bride.

After the couple left the ceremony and a luncheon, they went on honeymoon to Queen Victoria's residence, Osborne House, on the Isle of Wight.

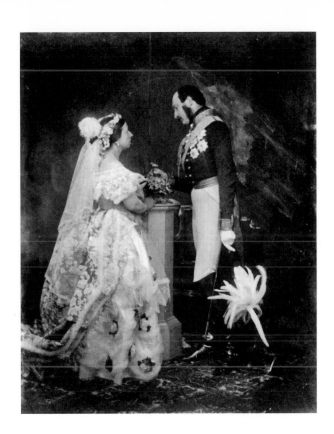

Queen Victoria and her beloved Albert. This view was a re-enactment of their wedding.

QUEEN VICTORIA AND ALBERT SAXE-COBURG-SAALFELD

This was a love match made in heaven. At first, Victoria was dismissive of her cousin Albert, as she thought of him as a friend, but nothing more. When she met him later, it was love at first sight. Cupid's bow struck her right through the heart!

Queen Victoria

Alexandrina Victoria was born on 24 May 1819 at Kensington Palace. Her father, Prince Edward, had died when Victoria was a baby, and her mother, the Duchess of Kent, looked after her. At the time she was born, she was fifth in line to the throne, after the Prince Regent (George IV), the Duke of York, and the Duke of Clarence (William IV) and her father. All, except Victoria's father, died without leaving any off-spring, so she was next in line to the throne.

Victoria spent a very isolated childhood at Kensington Palace. Her mother took complete control over everything Victoria did, including who she could meet. Her mother insisted on sharing a bedroom with her and deciding on her every move. Sir John Conroy, was Chief Attendant to the Duchess of Kent during this time, and had a very negative impact on her life. Her mother tried to get Victoria to appoint him as her Private Secretary, but Victoria refused.

The Duchess of Kent and her brothers tried to engineer a marriage between the young Victoria and Prince Albert when she was seventeen. Although she had found him attractive and charming, she felt she was not ready to marry.

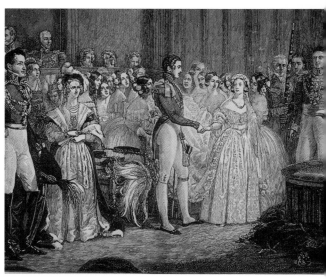

Above: Queen Victoria and Prince Albert.

Left: Queen Victoria resplendent in her finery.

Less than a month after Victoria turned eighteen, King William IV died and Victoria became Queen. Her coronation was on 28 June 1838. She was still required to live with her mother as she was unmarried, but she banished her to a small apartment in Buckingham Palace. The only way to avoid her domineering was by marriage.

In October 1839, the Queen met Albert for a second time. She still found him charming and proposed to him five days after he arrived at Windsor.

Prince Albert

Albert was the second son of Ernest III, Duke of Saxe-Coburg-Saalfeld, and his first wife, Louise of Saxe-Gotha-Altenburg. He was born at Schloss Rosenau on 26 August 1819. Albert had a close relationship with his brother, but his parents did not have a good marriage. They separated and his mother was exiled from Court when he was five. The boys were home-educated by tutors and Albert studied law, political economy, philosophy and art history at the University of Bonn. In 1836, it was decided by his uncle, father and aunt that he should marry. The most suitable candidate would be Victoria, heiress presumptive to the British throne.

He was, at first, quite unpopular with the British public. He was not in the same aristocratic league as the Queen, and there was an anti-German feeling around at the time. A peerage was refused by Parliament, but Albert didn't want it. However, within time his popularity grew, especially as the public saw his affection for the young Queen and for their country, and the Queen was able to grant him the title Prince Consort.

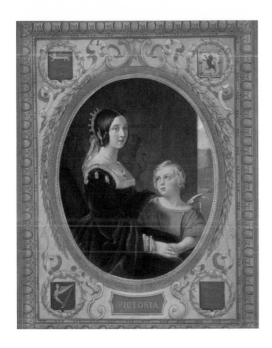

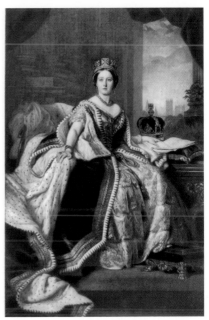

Above left: Queen Victoria and the Prince of Wales.

Above right: The young Queen Victoria in her Coronation robes.

Below left and right: The dashing Prince Albert, who tragically died while still quite young.

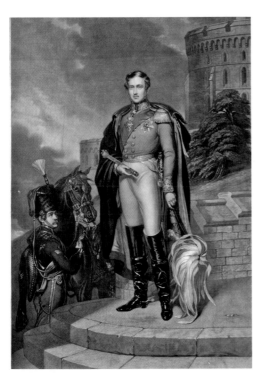

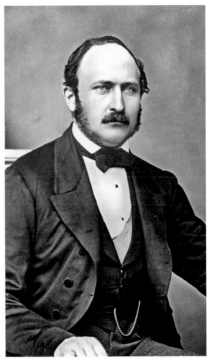

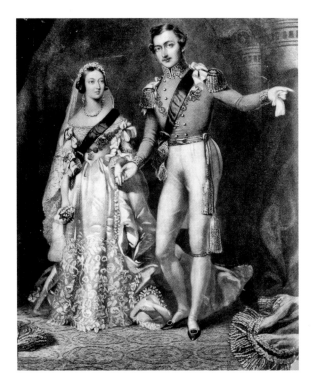

Victoria and Albert after their wedding.

The Wedding

The wedding of Queen Victoria and Prince Albert took place on 10 February 1840 at the Chapel Royal in St James' Palace. Although heavy rain fell, crowds turned out to see the processions. The Queen made her way by carriage from Buckingham Palace to St James' Palace at 12 o'clock. As she entered her carriage, a twenty-one-gun salute sounded. After arriving at St James' she proceeded to the Queen's Closet, where she waited for thirty minutes until everything was ready and in place. Prince Albert's procession moved first. He wore a Field Marshal's uniform with large white satin rosettes on his shoulders. The Queen's procession glided through various rooms to the Chapel. The procession was made up of dignitaries, twelve bridesmaids, maids of honour, six gentlemen at arms and various other members of the royal household.

Victoria wore a dress of white satin, trimmed with orange flower blossoms. Her head-dress was made up of orange blossoms and her veil was made of Honiton lace. She wore a very large pair of diamond earrings and a diamond necklace. The bridesmaids and train-bearers were in white. The ceremony was conducted by the Archbishop of Canterbury and the Duke of Sussex gave the bride away.

After the ceremony, the Queen crossed to where the Dowager Queen was standing and gave her a kiss. Then, Victoria and Albert left the Chapel and made their way back by carriage to Buckingham Palace. The royal couple had a wedding breakfast and a large wedding cake and then spent their honeymoon at Windsor Castle.

After the wedding, Victoria's mother was effectively banished and evicted from Buckingham Palace to Ingestre House in London's Belgravia. Albert did try to defrost relations between mother and daughter, but this only thawed gradually over the years.

Queen Victoria's children

Although Victoria mostly married for love, her children became pawns in a game of strategy with the other European royal families. She married her sons and daughters off so that Britain would have a foothold in many European countries, and therefore, making Britain more powerful and influential in European royalty. Her children were:

Child	Became	Country/Region	Married
Victoria	Empress	Germany	Frederick III
Edward	King	Britain	Alexandra of Denmark
Alice	Grand Duchess	Hesse	Louis IV, Grand Duke
Alfred	Duke	Saxe-Coburg	Grand Duchess Marie and Gotha Alexandrovna of Russia
Helena	Princess Christian	Schleswig-Holstein	Prince Christian
Louise	Duchess	Argyll	John Campbell, 9th Duke
Arthur	Duke	Connaught	Louise Margaret of Prussia
Leopold	Duke	Albany	Princess Helena of Waldeck and Pyrmont
Beatrice	Princess Henry	Battenberg	Prince Henry

Of Victoria's grandchildren, twenty-six out of forty-two married into aristocratic European families, thus forming an alliance with these areas.

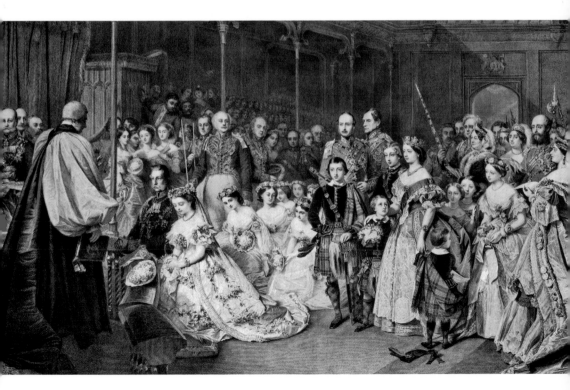

Princess Victoria.

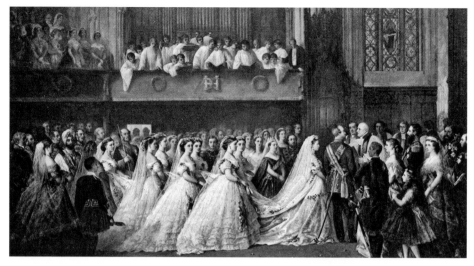

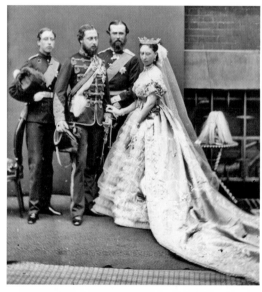

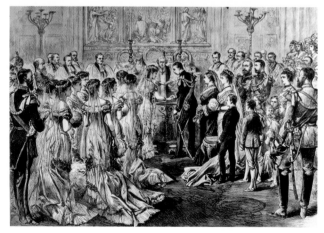

Top: Princess Helena marries Prince Christian of Schleswig-Holstein.

Middle left: Princess Alice and Louis IV, Grand Duke of Hesse.

Middle right: Princess Arthur of Connaught.

Left: The wedding of Prince Arthur, Duke of Connaught to Louise Margaret of Prussia.

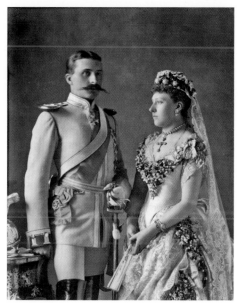

Princess Beatrice and Prince Henry of Battenberg.

'MINOR' ROYAL MARRIAGES
PRINCE ANDREW AND SARAH FERGUSON

Andrew and Sarah were married at Westminster Abbey on 23 July 1986. The Archbishop of Canterbury conducted the service and Prince Edward was his supporter.

The bride wore a duchesse satin dress designed by Lindka Cierach, a London-based designer. It had a scooped neck, with embroidery and bugle beads. The shoulders were padded and had bows. The full-length skirt had a bow on the back, leading to a seventeen-foot-long train. The train had various items embroidered on it relevant to the couple's life, such as A and S for Andrew and Sarah, and an anchor for Andrew's naval career. Her head-dress was made up of gardenias and, at the end of the ceremony, the flowers were taken away to show a diamond tiara, lent by the Queen. Her bouquet was in an 'S' shape with lilies, yellow roses, gardenias, lilies of the valley and a sprig of myrtle. The Duke wore his Naval Lieutenant's uniform.

Sarah had four bridesmaids and four page-boys, including Zara Philips, Prince William and Peter Philips. The girls were in pale peach ballerina length dresses, carrying hoops dressed with flowers, and flowers in their hair. The boys wore outfits modeled on Royal Navy midshipmen's uniforms from 1782 with straw boaters.

The wedding breakfast was again held at Buckingham Palace where guests were served lamb with mint sauce, stuffed eggs and strawberries and cream. The wedding caked was six foot tall, with six tiers.

The couple had a wedding party for 300 guests at Claridges Hotel in London and honeymooned in the Azores.

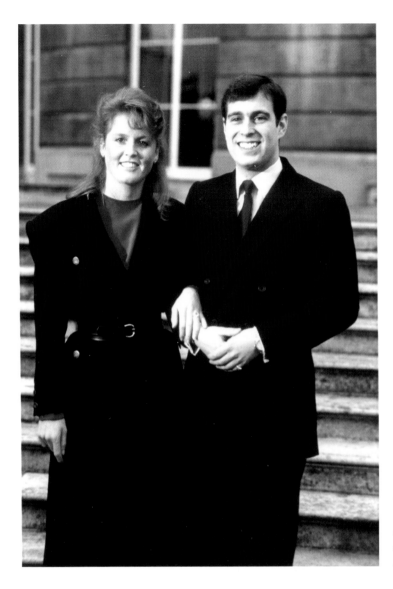

Prince Andrew and Sarah Ferguson on the day their engagement was announced.

PRINCESS ANNE AND TIMOTHY LAURENCE

Princess Anne wed Commander Timothy Laurence on 12 December 1992 at Crathie Church, near Balmoral. The couple first met initially when Commander Laurence served briefly as a Navigating Officer on board the Royal Yacht *Britannia*, although they met again when he was serving as an Equerry to The Queen in the early 1990s.

This was a private family ceremony. Under Church of Scotland law, divorce is viewed slightly differently than in England. People who have been married before, with an ex-spouse still living, can remarry in the church.

Anne wore a simple white suit with black hat and shoes, and Mr Laurence was in his Royal Navy uniform. A celebration was held on the Balmoral Estate's Craigowan Lodge

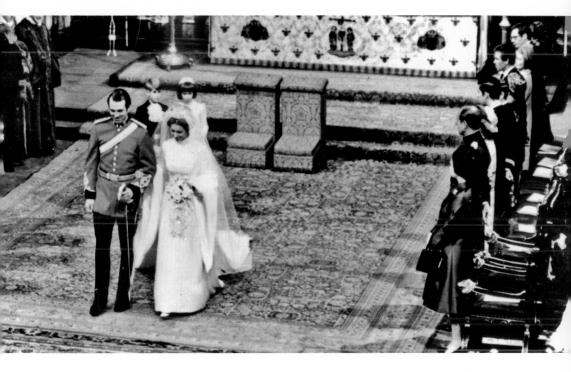

Princess Anne and Captain Mark Philips walking away from the alter. In the background are Pageboy Prince Edward and Bridesmaid Lady Sarah Armstrong Jones.

PRINCESS ANNE AND CAPTAIN MARK PHILIPS

Princess Anne's first marriage was to Captain Mark Philips on 14 November 1973 – which happens to be Prince Charles' birthday. The wedding took place at Westminster Abbey.

The bride wore a white tudor-style dress with medieval sleeves by Maureen Baker, from Susan Small and the groom wore his Queen's Dragoon Guards uniform. Princess Anne's bridesmaid was her cousin, Lady Sarah Armstrong Jones, and her page-boy was her brother, Prince Edward.

After an appearance on the balcony at Buckingham Palace, they had a wedding lunch. Then off to the White House Lodge at Richmond Park before travelling to Barbados. There they boarded the Royal Yacht *Britannia* and spent eighteen days relaxing at sea.

PRINCESS MARGARET AND ANTHONY ARMSTRONG-JONES

Twenty million viewers tuned in to watch the wedding of the Queen's sister, Princess Margaret, as she wed Mr Anthony Armstrong Jones at Westminster Abbey on 6 May 1960. It was a beautiful spring day, and the Princess arrived at the Abbey in the Glass Coach.

Margaret looked like a true princess as she stepped into the Abbey in a Norman Hartnell creation. The dress was made of white silk organza, cinched at the waist, and the silk skirt was hung over tulle petticoats. It also had a V-neckline and long, slim sleeves to suit Margaret's delicate frame. Margaret wore the Poltimore tiara – made in 1870 by the Queen's Jewellers, Garrard's for Lady Poltimore, wife of Queen Victoria's Treasurer – and had a

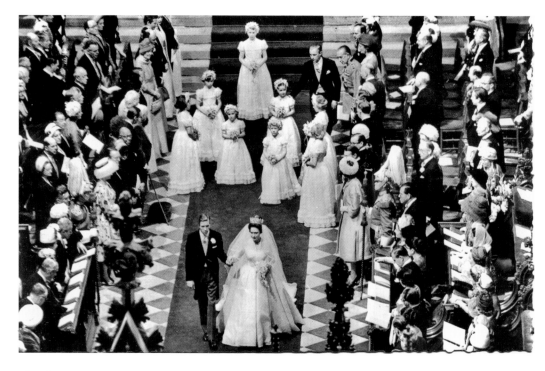

The glamorous Princess Margaret and her new husband Anthony Armstrong-Jones walking back down the aisle of Westminster Abbey.

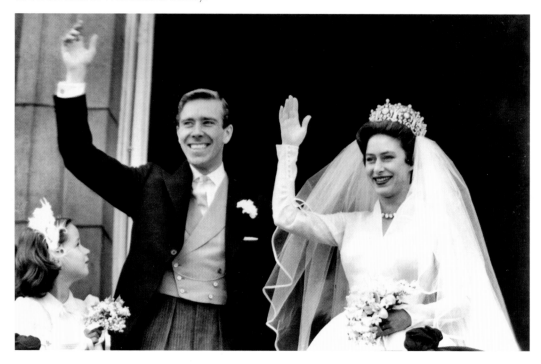

Princess Margaret and Anthony Armstrong-Jones wave to the crowds outside Buckingham Palace.

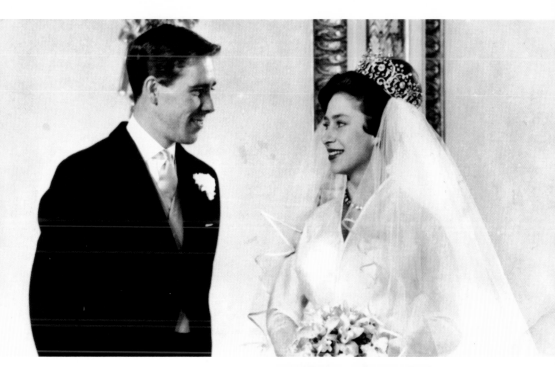

Above: Princess Margaret and her new husband enjoy a quiet moment during the official photographs.

Right: Princess Margaret and Mr Armstrong-Jones leave Westminster Abbey.

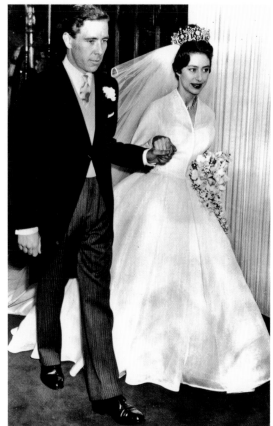

long silk organza veil. Her bouquet was of orchids. Mr Armstrong Jones wore a morning suit. The eight bridesmaids wore Hartnell-designed, ballerina-length dresses. The couple honeymooned on the Royal Yacht *Britannia* around the Caribbean.

PRINCE AND PRINCESS MICHAEL OF KENT

Prince Michael of Kent is the grandson of George V and Queen Mary and is the Queen's cousin. He married Baroness Marie-Christine von Reibnitz on 30 June 1978 in a civil ceremony at the Rathus in Vienna. This was because Marie-Christine was Catholic and divorced. The marriage itself was controversial because of this, so Prince Michael had to renounce his right to the British throne.

PRINCE EDWARD AND SOPHIE REES-JONES

Prince Edward met Sophie at a photoshoot. He was scheduled to pose for a photograph with the former tennis player, Sue Barker, for the Prince Edward Challenge. Sue could not make it, and Sophie stepped in to pose for the photograph. Soon after a romance developed.

Edward married Sophie on 19 June 1999 – Sophie's father's birthday – at St George's Chapel, Windsor. The wedding started at 4.30 p.m. Guests were asked to wear evening wear and no hats. Coaches and mini-buses brought the 550 guests to the Chapel. These guests include royalty, actors, friends and family. Sophie arrived in a glass-topped Rolls-Royce.

Sophie's dress was by the London designer Samantha Shaw. The dress was of silk crepe and organza in an oyster shade with a train. It was embroidered with 325,000 cut-glass beads and pearls. The dress had a V-neck and a medieval design. The Queen lent Sophie a tiara and Prince Edward gave her a black and white pearl necklace with a cross pendant and matching earrings. The bride's bouquet was made up of roses, lily of the valley, freesias and stephanotis. Edward wore a morning suit.

The bridesmaids and page-boys were dressed in black and white. These outfits were loosely styled on the Knights of the Garter. Sophie had two bridesmaids and two page-boys.

On leaving the Chapel, the royal family stepped into Ascot landaus and made their way through Windsor to the reception at St George's Hall. The newlyweds continued the unconventional style by having a self-service dinner. The menu included smoked haddock coulibiac and beef stroganoff, followed by fresh raspberries.

After leaving the reception they went to the Royal Lodge to stay with the Queen Mother. Next morning they had a 'brunch' at their new home at Bagshot Park. Then it was off to Balmoral. Unlike other couples, Edward and Sophie did not take a long honeymoon. They spent a couple of days at Balmoral, then it was back home and back to work.

❧ CHAPTER 2 ❧
The Hanoverians

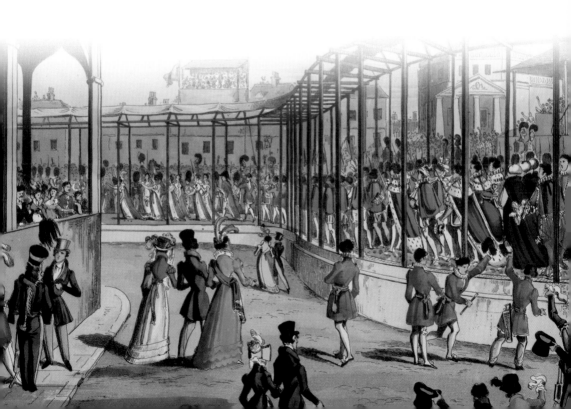

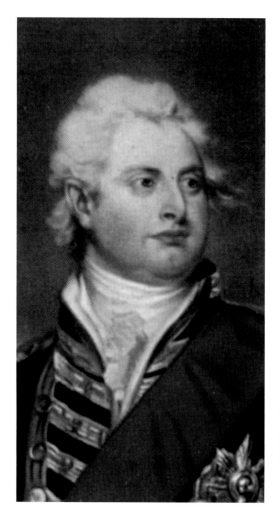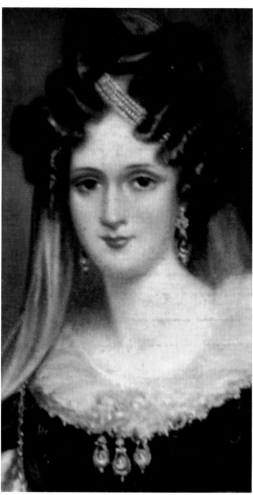

William IV and Queen Adelaide.

WILLIAM IV AND ADELAIDE OF SAXE-COBURG AND MEININGEN

William was an interesting character. Although there is not really much to say about his wedding, there is a great deal to say about his behaviour before and after marriage. William had lived with an Irish actress named Dorothea Bland for about twenty years. She was known by her stage name of Mrs Jordan. By this lady, he had ten illegitimate children. He could not marry Dorothea because the King did not approve, so William decided to co-habit instead. The affair ended in 1811.

After the affair ended, William tried to marry heiresses to ensure that he had money, but this did not work. However, when William's niece and heir presumptive died in childbirth in 1817, this meant that there was no heir to the British throne. His two brothers (the Prince Regent and the Duke of Cambridge) and himself started a race for the throne. His brothers' wives were past the age for having children and his brothers were unhealthy. Therefore, the front runner was William.

William eventually found a bride in Princess Adelaide of Saxe-Meiningen. She was in her mid-twenties and half William's age, but the marriage appeared to be a happy one. While they did have children, none of them survived through to adulthood. The throne was eventually passed to his niece, Princess Victoria of Kent (later Queen Victoria).

GEORGE IV AND CAROLINE OF BRUNSWICK

Today's media would have had a field day with this marriage! Caroline was the first British monarch to be tried for adultery. After an affair with Mrs Mary Robinson, an actress, George had a secret marriage to Mrs Maria Fitzherbert, who was a Catholic widow. This marriage had to remain a secret as the Royal Marriages Act would have deemed it illegal.

Therefore, in 1795, he entered a marriage with his cousin, Caroline of Brunswick. This was forced because George was in debt and Parliament would only pay these off if he got married and produced an heir to the throne. As he did not want to marry her, he drank himself into a stupor before the marriage and passed out on the bedroom floor! However, astonishingly a child was conceived – Princess Charlotte – and George was saved.

George refused to live with his wife and then, after a year, told her she could go and do what she liked! Therefore she did. Unfortunately, they had not divorced and her behaviour was unbecoming of a future Queen. Parliament decided to dissolve the marriage, but after a brilliant defense, the Lords dropped the case.

When his father died and George became King on 29 April 1821, Caroline was still adamant that she would be crowned Queen. She turned up at the ceremony but the door was shut in her face. She died nineteen days after the coronation.

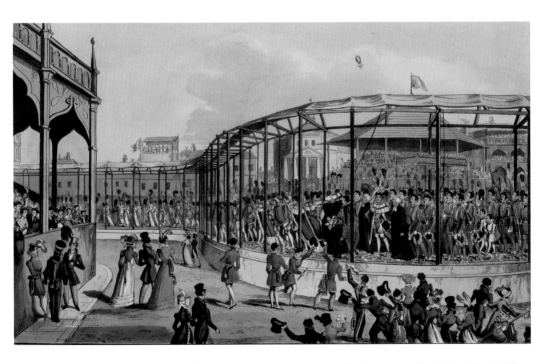

The Coronation procession of King George IV was an equally important day in the King's life.

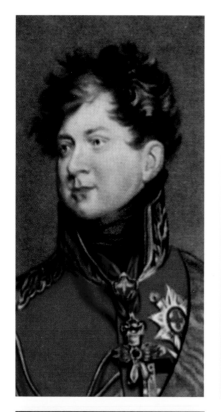

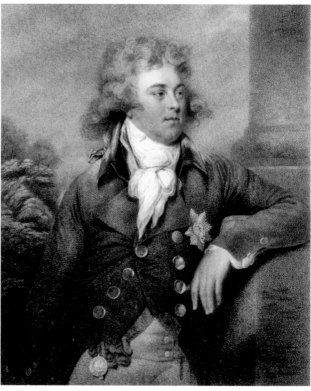

Above left and right: George IV reigned for a decade between 1820 and 1830.

Left: Caroline of Brunswick and George were married in 1795 but the marriage was not a happy one and the couple spent much of their married lives separate.

Caroline returned to Britain when George was crowned, determined to be recognised as Queen.

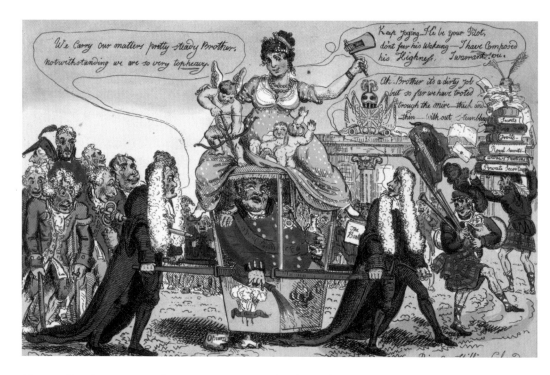

Many political cartoons and caricatures were made of the obviously unhappy couple. The top image depicts Caroline on George IV's sedan chair, trying with the help of Cupid to attract George again. Below is shown George IV as Don Giovanni, surprised by the sudden arrival of his wife, Caroline, as Donna Anna, lately returned from Italy, during the wedding feast scene, at which a number of bare breasted women are present; on the left, Lord Castlereagh, playing the role of Leporello, holds a long list of the King's female conquests.

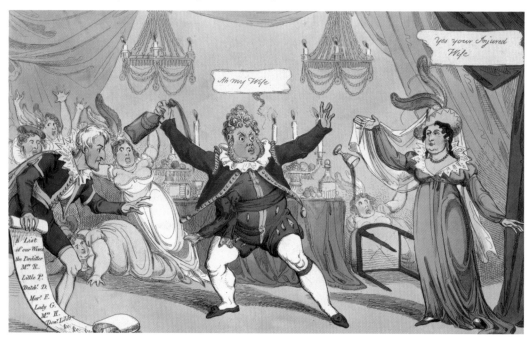

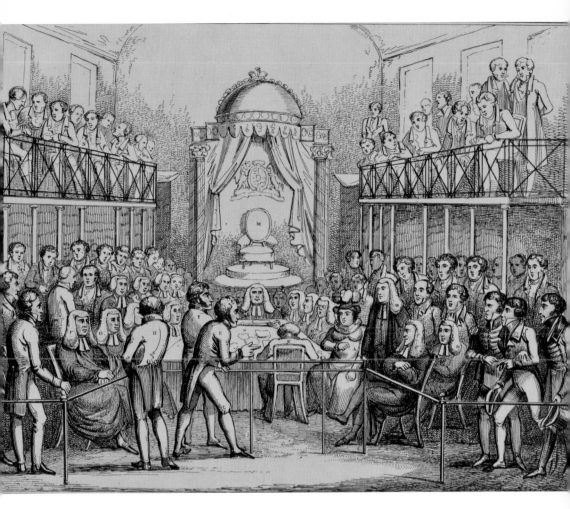

The Trial of Queen Caroline. George tried to get rid of Caroline using the law, but only succeeded when she died in 1821.

GEORGE III AND CHARLOTTE OF MECKLENBURG-STRELITZ

The Royal Yacht *Royal Caroline*, was renamed when it brought Princess Charlotte of Mecklenburg-Strelitz to Britain to marry George III. It was accompanied by the other royal yachts, *Mary, Katherine, Augusta* and *Fubbs*. However, all did not go according to plan. A three-day voyage turned into a nine-day nightmare after a storm, and it was decided to land temporarily at Harwich instead of making the full voyage to Greenwich. So, the royal yacht arrived at Greenwich on 7 September 1761.

The couple were married on nine o'clock on 8 September. The Archbishop of Canterbury performed the service at the Chapel Royal at St James' Palace. Charlotte was escorted down the aisle by George III's brother, the Duke of York. The wedding was followed by a reception.

George III, who was the first English-born and English-speaking monarch since Queen Anne.

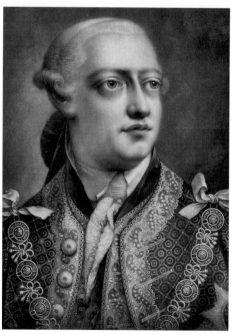

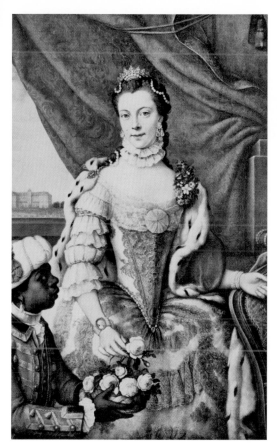

This page: Charlotte of Mecklenburg-Strelitz took no part in state affairs, but ran a tight household, with little frivolity. She was born in 1744 and died two years before her consort in 1818.

A political cartoon showing Charlotte and George III in control of the finances, by taxing the rich to reduce the National Debt.

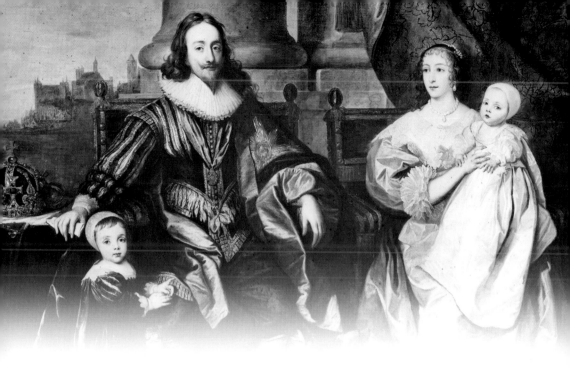

❧ CHAPTER 3 ❧
The Stuarts

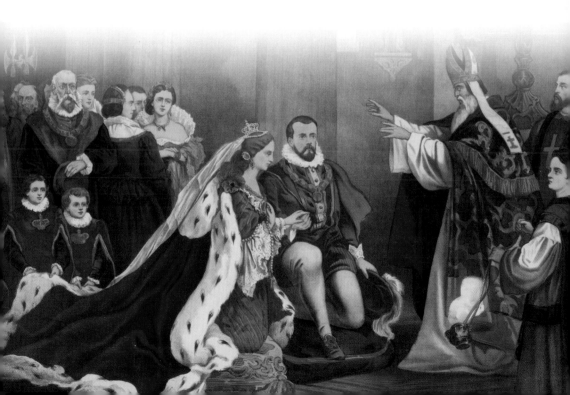

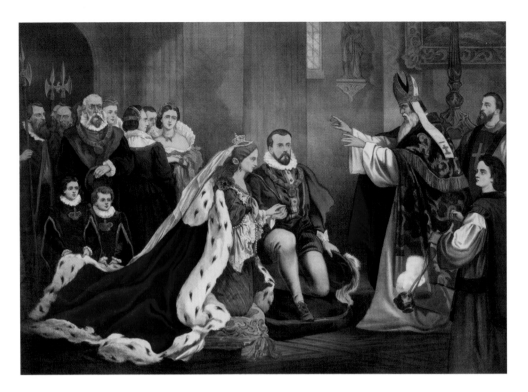

The marriage of Mary, Queen of Scots to Lord Darnley.

MARY, QUEEN OF SCOTS AND LORD DARNLEY

Mary was the lady who changed the course of history. Although born and crowned Queen in Scotland as an infant, she was sent off to France at the age of five, and Scotland was ruled by Regents. She married the Dauphin of France on 24 April 1558 when she was fifteen. When he ascended the throne in 1559 as Francis II, Mary became Queen Consort. In December 1560, Mary was widowed and returned to live in Scotland.

A poet gave an account of their wedding: they scattered gold and silver amongst the people (the Scots call it a 'scramble' or 'poor oot' and it was traditional at a Scottish wedding. All the children would run to pick up the coins).

The French always maintained that through her grandmother, Margaret Tudor, she was the rightful Queen of England as well as Scotland. Mary's second marriage was to her cousin, Lord Darnley in February 1565. This was not a happy union. He treated the Queen terribly and his supporters killed her favourite confidante, her Italian teacher, David Rizzo, when Mary was six months pregnant. Unfortunately, she could do nothing about this until her child was born, except lull Darnley into a false sense of security. Mary gave birth to a son, James. Soon after, Darnley was involved in an unfortunate explosion in a house he was staying in. He and his manservant both died.

Her third husband was James Hepburn, the Earl of Bothwell. This marriage was too much for some of Mary's sympathizers. Bothwell escaped to Norway via the Orkneys, but Mary was imprisoned on Loch Leven where she miscarried twins. In 1567 she abdicated in favour of her infant son, James, who became King James VI of Scotland, and later James I of England.

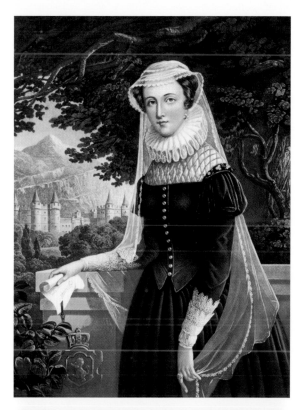

Mary, Queen of Scots as a young woman. She was eventually beheaded at Fotheringay Castle, it taking two strikes to sever her head.

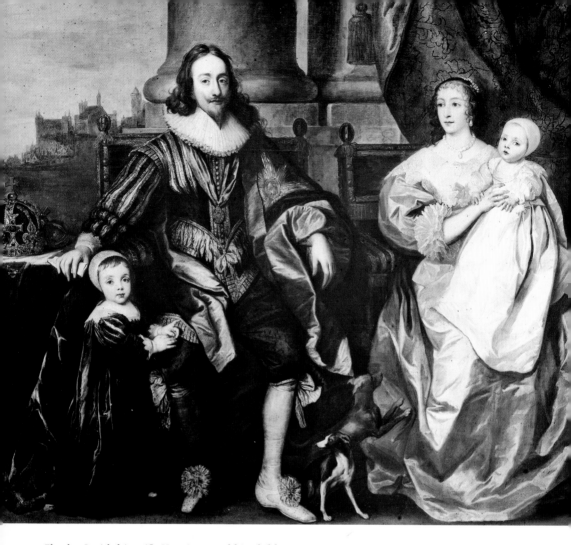

Charles I with his wife Henrietta and his children.

CHARLES I AND HENRIETTA MARIA

Charles was the son of James I and Anne of Denmark. His reign was a bloody one, stemming from his belief in the divinity of Kingship. This angered Parliament and England's bloody civil war was the result. He was beheaded in 1649. His wedding to Henrietta Maria took place in 1625, the year he was crowned. He was married in proxy in France, before his opponents could object to him wedding a Catholic and the couple came together at Canterbury on 13 June 1825 to be wed in person.

Henrietta Maria, the daughter of Henry IV, of France, left England in 1644, not returning until the restoration of the monarchy, which saw her son, Charles II, become King. Another of her sons became James II. She died in St Denis. The American state of Maryland was named after her.

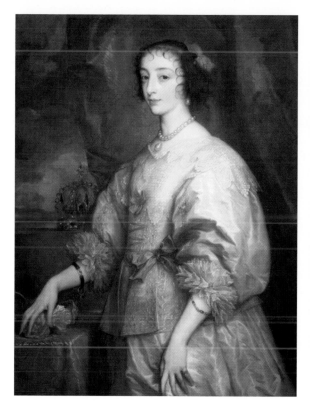

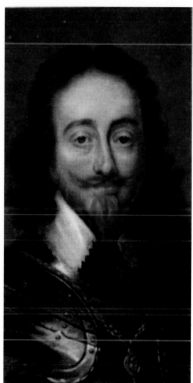

Above left: Henrietta Maria was born in 1609 and outlived her husband by twenty years., dying in 1669. In 1644, she left England for a life of poverty and suffering in Europe, before returning upon the Restoration of the Monarchy.

Above right: Charles I's reign presided over the greatest war ever in Britain. He was very enlightened and was a major patron of the arts. He was executed after a trial which shocked much of the civilized world of the time.

Right: Henrietta Maria.

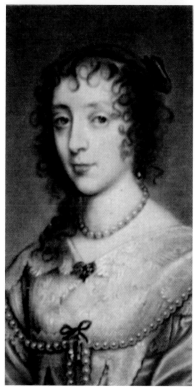

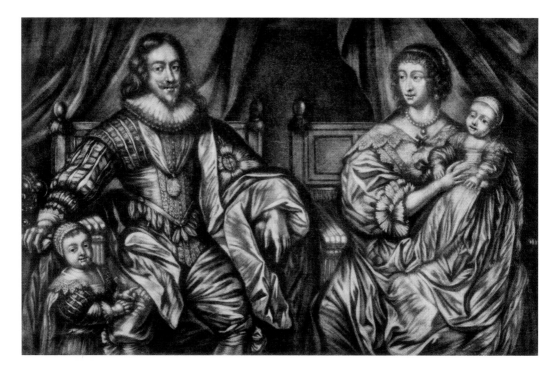

Two of Charles I's sons grew up to be King, being Charles II and James II.

CHARLES II AND CATHERINE OF BRAGANZA

While not many details are known about the wedding of Charles II and the Portuguese Catherine of Braganza, it is worth noting why they were married. As with so many royal marriages of the time, it was a strategic alliance to keep the peace, strengthen links with foreign countries and to increase wealth. Charles was restored to the British throne in 1660.

As part of the marriage treaty, Catherine came with an impressive dowry of sugar (a rare commodity), plate and jewels. Also, she came with the right to free trade with Brazil and the East Indies and the ports of Tangiers and Bombay.

A Catholic matrimonial mass was held at Manueline Abbey of St Jerome, where Catherine was married by proxy on 23 April 1662. This was followed by a carnival and bullfight. Then Catherine left for England. After her arrival in Portsmouth on 14 May 1662, the King and Catherine then went through two more marriage ceremonies on 21 May – a Catholic one (in secret) and an Anglican one. The blue love-knots on her dress were snipped off and handed around to the guests.

As she was Catholic, and this was the law at the time, Catherine could not be crowned on the British throne, but Charles had affection for her and supported her throughout the marriage. Charles did take many mistresses during his time – the most famous being Nell Gwynne.

Top left and right: Charles II reigned from 1660 until 1685. He was lazy, but skilled in foreign affairs.

Bottom right: Catherine of Braganza was the daughter of the King of Portugal. She married Charles II in 1662. Like the marriage of Albert and Victoria, this was one of true love and devotion.

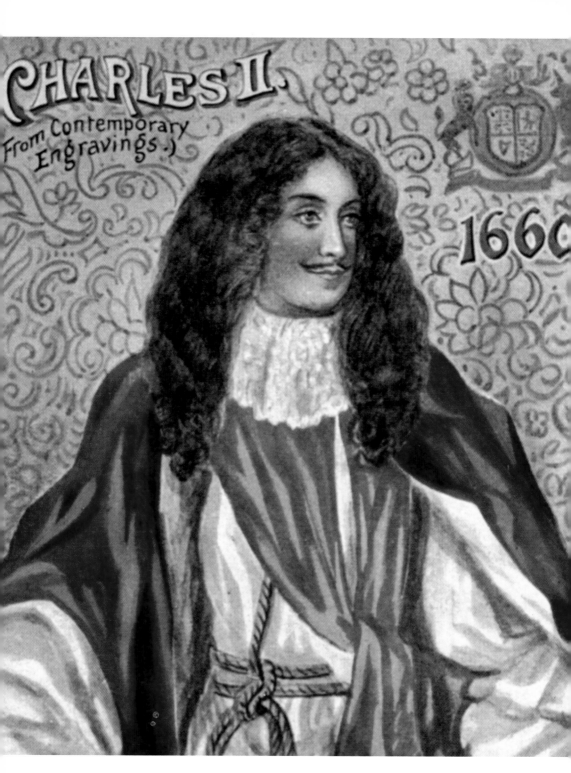

CHARLES II.
(From Contemporary Engravings.)

1660

Charles II had a strong interest in science, art and architecture, and many scientific achievements were made in Britain under his reign.

William and Mary. William was a grandson of Charles I and married mary, who was a daughter of James II. Together, they ruled until Mary died in 1694. William III died in 1702, on the eve of war with France.

WILLIAM III AND MARY II

This marriage was another strategic alliance. William took over the Scottish, English and Northern Irish thrones in the Glorious Revolution. Mary was betrothed to William of Orange at the age of fifteen and they were cousins. This would make William fourth in line to the throne after James, Mary and her sister Anne.

Mary did not really want to marry William but they did on 4 November 1677. The ceremony was at St James' Palace and the couple were married by Bishop Henry Compton. After this, Mary left with William to travel to the Netherlands.

Following the birth of her younger brother James, it was inherent that James would be brought up a Catholic, and this was unacceptable to Parliament, so William mounted a campaign – the Glorious Revolution – to invade Britain and save it from Catholicism. Although Mary was the rightful heir to the throne, she and her sister stepped aside and allowed William to take control, with Mary as his pillar of support.

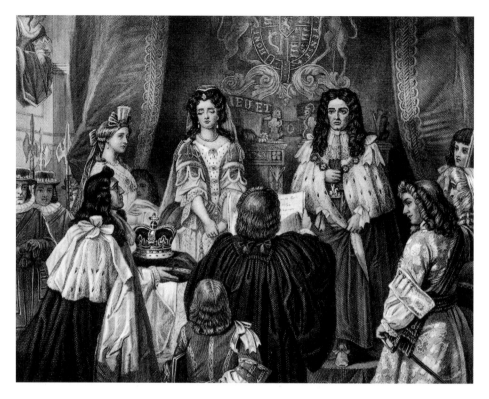

The crown was offered to William and Mary by the lords and commons at Whitehall on 12 February 1689. Engraving by H. Bourne after E. M. Ward. From the book *Illustrations of English and Scottish History* Volume II.

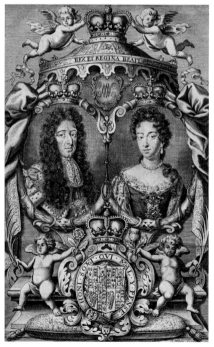

Two views of Mary and William, the first showing the pair together, but published in 1703, after the death of William III.

The title page of a book entitled *The Present State of England,* showing William III in his Coronation robes.

William III in his fine robes.

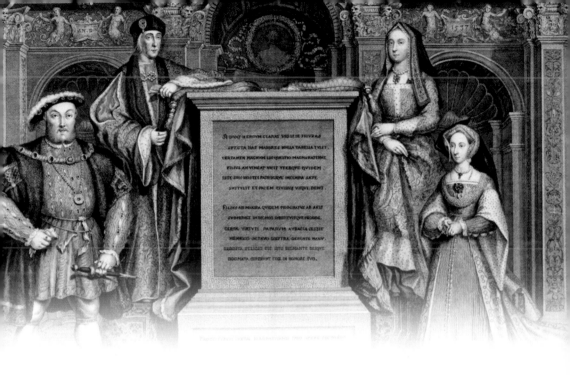

❦ CHAPTER 4 ❦
The Tudors

Above and opposite left: Henry VIII, England's most famous King, and husband of six wives.

Opposite right: Catherine of Aragon. Henry VIII was her second husband, the first being Henry VII's first son, Arthur. Her divorce saw the breach with Rome and, after the annulment, her life was spent in harsh confinement.

Henry VIII had the most famous marriages in the Royal Family. He had six wives, all in their own way, interesting characters, with interesting fates.

Divorced – Catherine of Aragon, mother of a son who died in infancy and one daughter, Mary
Beheaded – Anne Boleyn, mother of Elizabeth I
Died – Jane Seymour, mother of Edward VI
Divorced – Anne of Cleves
Beheaded – Catherine Howard
Lived – Catherine Parr

Catherine of Aragon

The Spanish princess was originally married to Henry's brother, Arthur. They married in Old St Paul's Cathedral on 14 November 1501. After the wedding, the couple moved to Ludlow Castle. However, after a year of marriage, Arthur died. The strategic alliance between England and Spain was threatened, and the King (Henry VII) did not want to her return to Spain and take her dowry with her. So she was betrothed to his younger brother Henry. The marriage was to take place when he was old enough to wed. However, prior to his death, Henry VII wasn't too keen on being allied with Spain and the young Henry was ordered to reject the betrothal.

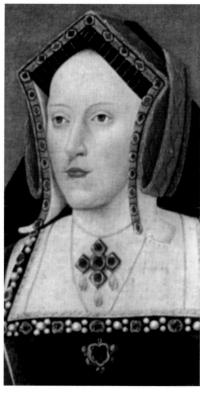

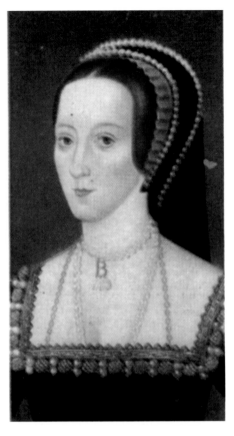

Left: Anne Boleyn, the first of Henry's wives to lose her head. Her only surviving child was Elizabeth I.

Above: Henry and Anne Boleyn.

After Henry VII died and Henry VIII became King, he married Catherine on 11 June 1509, with the Coronation being on 24 June. Henry and Catherine were married at Greenwich Church in a private ceremony. Catherine had a number of miscarriages and still-births. Only one child survived until adulthood – Mary. While the King tried to remain patient at her not producing a male heir, his attentions were wandering to a new lady named Anne Boleyn.

Anne Boleyn

Anne was Catherine's maid of honour and was much younger than Henry. As the marriage to Catherine was producing no living male children, Henry was now looking for someone to produce some. So, Henry sought an annulment for his marriage to Catherine, but instead the Pope forbade Henry to marry again before Rome reached a decision. A plot ensued, and Catherine was banished from Court circles. Later, he secretly married Anne Boleyn as she had become pregnant. Henry wanted this child to legally become king. After a court hearing on 23 May 1533, the special court deemed Henry and Catherine's marriage illegal as it was never consummated. Then, they ruled that Anne and Henry's marriage was legal on 28 Mary 1533.

Anne did bear Henry a girl, born in September 1533. This baby was to become Elizabeth I. Henry was furious at the child being a girl. Anne later miscarried a son in 1536. She was executed on 19 May 1536 for alleged charges of witchcraft, incest and adultery. But probably the real reason was that she couldn't give him a son.

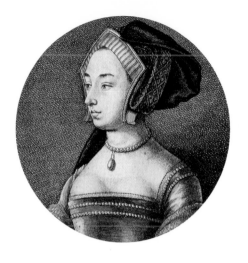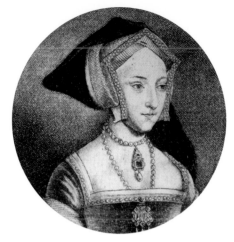

Above left: Anne Boleyn.

Above right: Jane Seymour, Henry's favourite wife.

Below: Henry VIII with Jane Seymour.

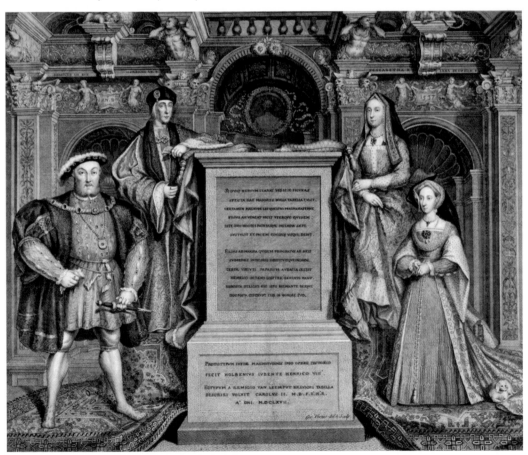

Jane Seymour

Henry married Jane Seymour within a day of Anne's beheading. Henry must have planned this marriage simultaneously with Anne's beheading, as while wedding cakes were baking and wedding clothes were being sewn, his second wife was being prepared for death.

Jane was Anne Boleyn's lady in waiting. Henry married her on 20 Mary 1536 at Wolfhall in Wiltshire. After a dinner, the bridal party went to Marwell, near Winchester. Henry gave this to the Seymours. Henry introduced the bride as Queen – although she was not crowed Queen at this point.

She was an unfortunate lady because she gave Henry what he wanted – a son, Edward – but died just twelve days after the birth. She was Henry's favourite wife and Henry wanted to be buried with her.

Anne of Cleves

Anne was a pawn in an alliance. Her father, the German Duke of Cleves, had originally betrothed her to Francis, son of the Duke of Lorraine when she was twelve. When her father had a dispute with Charles V, the Holy Roman Emperor, it was decided that King Henry was a more suitable ally than the Duke of Lorraine. Anne's betrothal was shelved and Thomas Cromwell started matchmaking between King Henry and either Anne or her sister Amelia. In order that he could choose, the artist Hans Holbein the Younger was dispatched off to paint them (as we would take a photograph today). Although he preferred educated and sophisticated women, Anne caught his attention.

Anne of Cleves was divorced relatively quickly, having been referred to by Henry as the 'Flemish mare'. Holbein had been sent to Flanders to paint a likeness of her, which, if events are to be believed, was rather flattering of Anne.

When she arrived in Britain, Henry was so anxious to see her that he went to Rochester, rather than wait at Greenwich Palace. Unfortunately, Henry was not too enamoured with his new bride and tried to find a legal way to get out of the marriage without offending her family. However, he couldn't and they were married on 6 January 1540 at Greenwich Palace, and the marriage went from bad to worse. The wedding night did not go well and six month later Anne was told to leave the Court. Henry then sought an annulment, which Anne agreed to. As recompense, she received many properties including Richmond Palace. After a while, Anne and Henry became friends and he looked on her more as a sister than an ex-wife.

Catherine Howard

Catherine was the daughter of Lord Edmund Howard, 2nd Duke of Norfolk. She was also a cousin to Henry's second wife, Anne Boleyn. Her father was not rich, and her uncle, Thomas, 1st Earl of Wiltshire, got his niece a place as lady-in-waiting to Anne of Cleves. As the King did not get on with his new wife, his wandering eye strayed towards Catherine and she became his mistress.

Henry married Catherine only three weeks after his marriage with Anne was annulled. After marriage, Henry did not really appeal to Catherine any more and they failed to produce a male heir. He was not ideal husband material any more, being overweight and foul-smelling due to an ulcer.

The start of her downfall came when Catherine had an affair with Thomas Culpepper. As this became known, she had to buy the silence of those in the know by offering them positions within the household. Two members of the royal household then made the situation known to the Archbishop of Canterbury, who in turn gave the King a letter with the accusations against Catherine. An investigation took place and she was found guilty of adultery. She was sentenced to beheading.

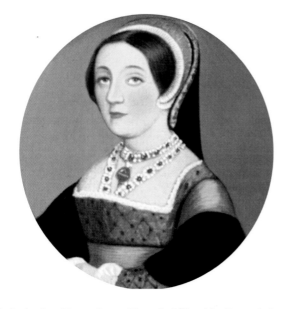

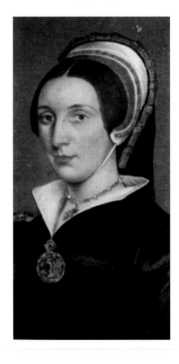

Catherine Howard was Henry's fifth wife. Committing adultery, Henry had her executed for treason in 1542.

Catherine Parr was married a total
of four times in her short life (1512-
1548). She had two husbands, both of
whom died, before meeting Henry.
She outlived him, marrying again
after his death. She died in 1548 at
Sudeley Castle, Gloucestershire.

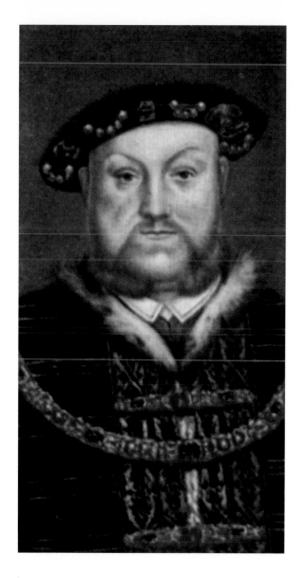

Henry VIII in his later years.

Catherine Parr

Catherine was seventeen when she first married Lord Borough, who was in his sixties. After he died, she then married Lord Latimer and attended the Royal Court with him. Catherine was still only in her early thirties when Latimer died and had fallen for Jane Seymour's brother. But King Henry intervened and she was not allowed to refuse. They married on 12 July 1543 at Hampton Court Palace.

Unlike his other wives, Catherine's main purpose was being a carer for the king and attending to his ailments. She was also step-mother to his children, and helped him to build a better relationship with his daughter, Mary. She also helped in the education of two of his children, Elizabeth and Edward.

The King died in 1547 after four years of marriage to Catherine. There should have been a happy end to this story, but after marrying Thomas Seymour, she died from puerperal fever, arising from childbirth. She was buried at Sudeley Castle, Gloucestershire.

Henry VII being crowned at Bosworth, after the battle that saw the death of King Richard III.

HENRY VII AND ELIZABETH OF YORK

Elizabeth of York had many connections to the King. She was the eldest child of Edward IV and sister of Edward V.

It was after an alliance made between her mother, Elizabeth Woodville, wife of Edward IV and Queen Consort, and Lady Margaret Beaufort, mother of Henry Tudor (later Henry VII). Henry had a very tenuous claim on the throne, but once he had claimed it, then he would marry Elizabeth and the Tudor and York's would be united. Elizabeth was used as a political pawn to bring peace between the Yorks and the Tudors.

Henry's army landed in Wales and fought at the Battle of Bosworth Field. After Richard III died during the battle, Henry took the Crown. He then married Elizabeth, as then there would not be an uprising from the Yorks. He was crowned on 30 October 1485 – after claiming the throne by conquest - and married Elizabeth on 18 January 1486 at Westminster Abbey. Elizabeth was crowned Queen Consort on 25 November 1487 – even though the throne was rightly hers after her father, brothers and uncle's deaths.

After the marriage, the War of the Roses were over and England became a peaceful nation once again.

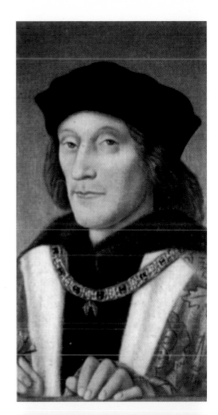

Henry reigned from 1485 until his death in 1509. He was responsible for the magnificent chapel at Westminster, but had few friends at Court.

Elizabeth of York was twenty when Henry took the crown at Bosworth. Their union sealed the end of the War of the Roses. Henry VIII was their second son.

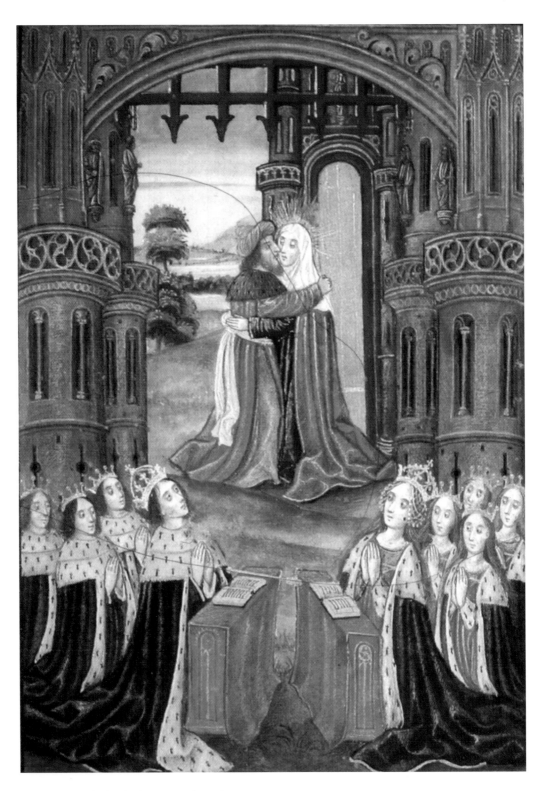

Henry VII and Elizabeth on a mediaeval manuscript.

❧ CHAPTER 5 ❧
The Plantagenets

HENRY · III · (1216)

Henry III had a long reign, succeeding King John in 1216 and dying in 1272. He was dominated by his wife and her relations, spending much money on expeditions to France and church building, including the Abbey at Westminster.

HENRY III AND ELEANOR OF PROVENCE

This king illustrates how to make yourself even more unpopular, by marrying someone who is not approved!

Henry III's marriage to Eleanor of Provence in 1236 did not prove popular because, although she was a beauty – she was known as La Belle – she did bring over to England a large amount of relatives – the Savoyards – from France, who promptly took up posts in the English government. This was not a popular move. Henry was betrothed to Eleanor on 22 June 1235, when she was only twelve. She was the second eldest of four daughters. All the daughters became Queens.

She was married to Henry on 14 January 1236, when she was only thirteen, at Canterbury Cathedral. She was dressed in a golden gown, which was fitted at the waist and fell to the floor in wide pleats. Then it was off to London, to be crowned at Westminster Abbey.

Eleanor was similar in many ways to modern day princesses. She became a fashion leader and her style was often copied by those at Court. On the official records, Henry III and Eleanor had five children, but there could be at least another four. The eldest of whom was Edward I, who married Eleanor of Castile.

Right: Edward I was a great soldier, who was known as the Hammer of the Scots. He took Scotland's Stone of Destiny, on which Scotland's Kings were crowned and took it back to Westminster Abbey, where it is still there to this day.
Above: Eleanor of Castile sucking blood from her husband, who had suffered a snake bite in France.

EDWARD I AND ELEANOR OF CASTILE

Eleanor was the first wife of Edward I and was renowned for her beauty. She married Edward in October 1254 at Burgos in Spain, when Edward was fifteen and Eleanor was just over ten. This marriage was politically motivated, but they were an example of enduring love. She often accompanied him on his Crusades and conquests as they could not bear to be parted.

Eleanor gave birth to sixteen children, six of whom survived into adulthood. She died on 28 November 1290 and the King erected memorial crosses at each place where her body had lain overnight. Nine years later he married Margaret, daughter of Philip III of France.

EDWARD I AND MARGARET OF FRANCE

While still grieving after the death his first wife, Edward decided that he should have another wife. After looking around, he approached Philip III of France with a view to marrying his daughter, Blanche, as this would make peace with France. However, it seemed that Blanche was already married, and instead Philip offered him one of his other daughters, Margaret, who was eleven. Edward was not happy and waged war on France for five years. Eventually, he did marry Margaret when she was sixteen and he was sixty. This took place on 8 September 1299.

Not long after, Edward left for a campaign fighting the Scots. After a period of loneliness in London, Margaret joined him. The King was very pleased by this. As the King's children were nearly the same age as Margaret, she became very close to them. She bore Edward three children, the last of whom she named Eleanor after his first wife. She was widowed at the age of twenty-six.

EDWARD I (1272

from the Choir of York Minster.

Edward I.

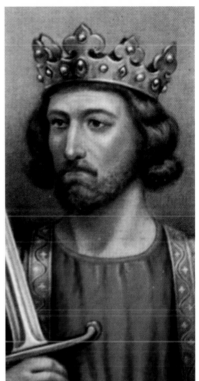

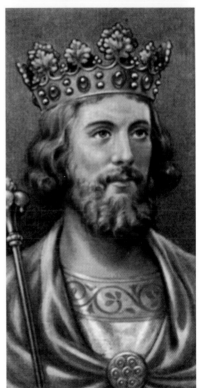

Above left: Eleanor of Castile.

Above right: Edward I.

Right: Edward II attempted to control Scotland, like his father, but was soundly beaten at the battle of Bannockburn in 1314. His wife had him murdered at Berkeley Castle, supposedly using a red-hot poker. He is buried in Gloucester Cathedral.

EDWARD II. 1307

From the Tomb at Gloucester.

Left: Edward II's tomb at Gloucester Cathedral.

Opposite: Paintings were like present-day photographs... they were snapshots of current events. This view shows Isabella of France with Roger Mortimer, her lover, during their invasion of England in 1325, an event that would ultimately lead to Edward's death. He abdicated early in 1327 in favour of his son, who became Edward III.

EDWARD II AND ISABELLA OF FRANCE

Isabella was the daughter of Philip IV of France and Joan I of Navarre. Edward II was keen to marry her because the French Royal Family was one of the most powerful in Western Europe.

She was married to Edward II at Boulogne-Sur-Mer on 25 January 1308 when she was twelve. Being from a wealthy royal family, her wardrobe consisted of velvet, taffeta and furs. She had two gold crowns and seventy-two head-dresses! However, all was not well when her new husband decided to sit with his royal favourite at the wedding party instead of her.

Throughout their marriage there were tensions between Isabella and Edward. After having her land and children removed from her, she sided with her brother, King Charles IV of France and, in the end, Isabella returned to England and seized the country from Edward, forcing the King to abdicate. To cut a long story short, Isabella was instrumental in the King's downfall. The King was moved to Berkeley Castle, Gloucestershire, in Gloucestershire, where he had an unfortunate accident involving a red-hot poker. Isabella became Queen Regent. The Queen's son, the future Edward III, felt that the Queen's right-hand man, Roger Mortimer, had too much power, and had him executed after a coup to regain the throne. The Queen lived her life out quietly in retirement.

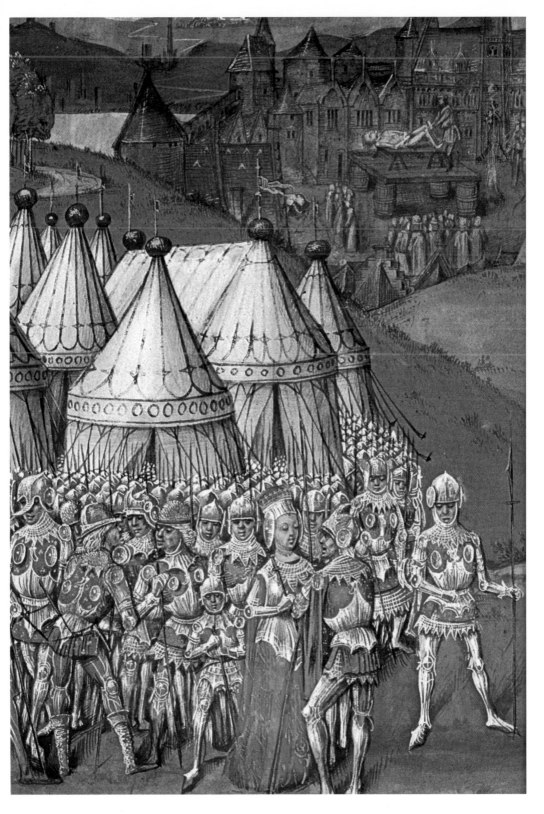

ALSO PUBLISHED BY AMBERLEY

Royal Encounters
Paul Ratcliffe

A fresh, informal insight into the daily working
lives of Britain's much loved and talked about
family – the Windsors.

ISBN: 978-1-84868-186-6

www.amberleybooks.com

ROYAL
ENCOUNTERS

PAUL RATCLIFFE